WILDWOODS HOUSES
THROUGH TIME

TAYLOR HENRY

To Jim
none of this
would have
been possible
with out your
grand father's &
father's dedication
to history
Taylor Henry
3/2/19

AMERICA
THROUGH TIME®
ADDING COLOR TO AMERICAN HISTORY

Dedicated to those who built the early homes of the Wildwoods,
and to the people who have cared for them through time.

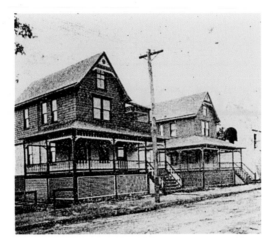

The Bower Cottages still stand on Maple Avenue. (WHS)

America Through Time is an imprint of Fonthill Media LLC
www.through-time.com
office@through-time.com

Published by Arcadia Publishing by arrangement with Fonthill Media LLC
For all general information, please contact Arcadia Publishing:
Telephone: 843-853-2070
Fax: 843-853-0044
E-mail: sales@arcadiapublishing.com
For customer service and orders:
Toll-Free 1-888-313-2665

www.arcadiapublishing.com

First published 2018

Copyright © Taylor Henry 2018

ISBN 978-1-63500-080-1

Typeset in Mrs Eaves XL Serif Narrow
Printed and bound in England

CONTENTS

PHOTO CREDITS

All historic photos were provided by the homeowners except where captions are followed by (WHS), which indicates photos from the collection of the Wildwood Historical Society, Inc. If the date of the photo is also in parenthesis, as in (WHS 1960), this indicates photos from the historical society's collection of tax record photos as well as the year of the photo. In some cases, these are the oldest known photos of properties. All modern photos were taken by the author unless otherwise noted.

Thanks

This book was made possible by the Wildwood Historical Society, founded by late Wildwood historian George Boyer, a native Philadelphian who moved to Wildwood *circa* 1932 and lived there until he died in 1976. Most of the Wildwoods' history would have been lost without his dedication to capturing the stories of early settlers before they died. Also crucial to this research was the late Leon Fulginiti (and his son Vincent Fulginiti) who donated dozens of city directories and thousands of photos and artifacts to the museum (they are stamped with "Stolen From Leon Fulginiti" as a joke). Thank you to the members, artifact donors and contributors of the Wildwood Historical Society, and especially board members and volunteers Al Alven, Jackson Betz, Karen Bohme, Al Brannen, Pam Bross, Vicki Bundschu, Judy Carr, Ben Errickson, Kathi Johnson, Dorothy Kulisek, Inge Laine, Nilda Langston, Larry Lillo, Mike Mattera, Robert Scully, Catina Simmons, Kathy Skouras, Cathy Tchorni, Virginia Wood, Anne Vinci, and Lew Vinci, all of whom contribute to this book or the preservation of the Wildwoods' history in different ways. Thank you to my mentors, Peter Brophy, Keith Forrest and Drew Kopp, also to Megan Atwood, Eric Reed, Laurie Johnson and Cathy Smith. And thank you to the homeowners who reached out with interest in having the stories of their homes told, the families who saved their photos and records, and the people who care for their historic buildings.

Resources

"A Century of Memories: Wildwood Centennial 1912-2012" presented by the City of Wildwood, 2012
Archives of the Cape May County Clerk's Office
"Ask the Builder" column by Tim Carter, *Washington Post*
"Better Than New: Lessons I've Learned from Saving Old Homes" by Nicole Curtis, 2016
"Borough of Anglesea 1885-1906: North Wildwood History Series Volume I" by W. Scott Jett, 2018
"Cape May County Through Our Eyes" by *The Press of Atlantic City*, 2007
"City of Wildwood Historic Architectural Planning Study" by John J. Olivieri, 1993
"Discovering the History of Your House" by Betsy J. Green, 2002
"Guardians of the Hereford Inlet" by Stephen M. Murray & Friends of the Hereford Inlet Lighthouse, 2010
"Millennials and Historic Preservation: A Deep Dive Into Attitudes and Values" by Edge Research, 2017
"The First Hundred Years: A Pictorial History of Wildwood Crest" presented by Wildwood Crest Centennial Committee, 2010
"The Gingerbread Age: A View of Victorian America" by John Maass, 1957
"WatchTheTramcarPlease.com"
"Wildwood By The Sea" by David Francis, Diane DeMali Francis and Robert Scully, Sr., 1998
Wildwood Historical Society, George F. Boyer Museum
"Wildwood Historic Preservation Commission," 1998
"Wildwood: Middle of the Island" by George F. Boyer, 1976
Wildwood Partners in Preservation
Wildwood Sun-by-the-Sea Magazine

INTRODUCTION

The history of the Jersey shore barrier island known as the Wildwoods goes back to the 1800s, but evidence of the resort town's turn-of-the-century founding are increasingly difficult to find. As the blue-collar alternative to fancier neighbors Cape May, Stone Harbor and Avalon, the Wildwoods became a center of vernacular architecture from several historic eras. In the late 1800s and early 1900s, working-class Americans filled the island with houses that fit their humble needs without skimping on quality or design. But as redevelopment over the decades slowly changed the landscape, many of the places that reflected the early age of Wildwood, Wildwood Crest, North Wildwood and West Wildwood were lost. Architectural treasures were unprotected, and their historic significance was forgotten or disregarded. Because of this, many visitors don't realize the Wildwoods are older than the island's famous midcentury motels. Not all was lost, though: hiding in plain sight along residential streets, often under vinyl siding and modern renovations, are many of the houses built and lived in by the founding fathers and pioneering people of the Wildwoods.

The oldest houses on the island were built with lumber from the trees that gave the Wildwoods their name. Their beams were recycled from the ships that brought settlers to the barrier island in the late 1800s. The nails and pegs hammered by hand have held these homes together for a century or more. Nor'easters and hurricanes failed to wash them away. The strength and quirkiness of the houses in the Wildwoods reflect the pioneers who built them.

The Lenni-Lenape were the first to navigate the unruly thickets of oak, cedar and holly trees that once covered the island accessible only by boat; they were followed by whalers in the 1700s. After many health-benefitting excursions to Five Mile Island, a group of developers from Vineland formed the Holly Beach Company and bought a tract of land toward the south end in 1882. Founder Joseph Taylor built the first house a year later, leading the way for more in the next few years. By the time Holly Beach became a borough in 1885, many gothic cottages and gingerbread-trimmed estates stood among the holly trees.

That same year, Anglesea—a borough named for the anglers who settled there—was established by developer Henry Ottens at the north end of the island. Working-class fishermen, many of whom were of Scandinavian descent, built plain, sturdy Craftsman homes or gothic cottages in which they would reside year-round. Upper-class beachgoers designed—as their second homes—grand Victorian manors inspired by the first permanent dwelling on the island, the stick-style Hereford Inlet Lighthouse, which was built in Anglesea in 1874. Anglesea became the borough of North Wildwood in 1906, then became the City of North Wildwood in 1917.

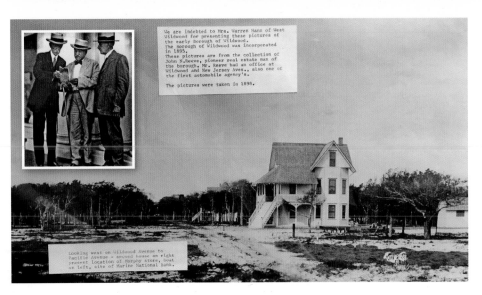

We are indebted to Mrs. Warren Hann of West Wildwood for presenting these pictures of the early Borough of Wildwood. The Borough of Wildwood was incorporated in 1895. These pictures are from the collection of John N. Reeve, pioneer real estate man of the borough. Mr. Reeve had an office at Wildwood and New Jersey Aves., also one of the first automobile agency's.

The pictures were taken in 1898.

Looking west on Wildwood Avenue to Pacific Avenue – second house on right present location of Murphy store, boat on left, site of Marine National Bank.

Pacific Avenue in 1898. Inset shows the Baker Brothers. (*WHS*)

In 1895, three brothers who were merchants from Vineland—Philip, J. Thompson, and Latimer Baker—established the Wildwood Beach Improvement Company, planning to make their fortune developing part of the island. They bought a tract between Anglesea and Holly Beach and named it Wildwood Beach, but the only way to get there was either by beach or by a foot trail made by the Lenni-Lenape. Wildwood Beach remained isolated until 1912, when officials in Holly Beach and Wildwood Beach voted to merge the two boroughs and form the City of Wildwood. Wildwood was an economic success for the Baker Brothers, bringing entrepreneurs who opened profitable hotels and landlords who maintained welcoming rooming houses. Streets were laid out, and the Lenni-Lenape's dirt trail became the outline of New Jersey Avenue.

The Baker Brothers saw more profit to the south of Wildwood, where a sand-dune-laden forest remained undeveloped. They dredged sand from Sunset Lake to level the ground and expand its size. The first house was built in Wildwood Crest in 1906. By the time Wildwood Crest became a borough in 1910, hundreds of Queen Anne Victorian manors with spacious yards full of blooming gardens made up the resort.

All three municipalities expanded at the same time as taste in architecture was evolving throughout America. The oldest houses on the island were cottages in Wildwood and North Wildwood built in the Gothic Revival style that took hold of America in the mid- to late-1800s. Because Gothic Revivalism fell out of style around 1880, which predates the Wildwoods, very few were built and remain standing, according to the 1993 City of Wildwood Historical Architectural Planning Study prepared by architect John J. Olivieri.

In the study, which proves Wildwood has notable historic architecture that needs to be protected, Olivieri also found rare but present instances of Italianate style—characterized by round arched windows, low-pitched hipped roofs and wide eaves with decorative brackets— and Victorian Second Empire, the era of Mansard roofs. Few were ever built on the island, as they also fell out of style around the 1880s.

The asymmetry and ornamentation of Queen Anne Victorian was vogue when the Wildwoods were being established, therefore many of the historic houses were built in this style. "The High Queen Anne style of 1880-1910 used a rich variety of materials and ornament in exciting combinations to offer its builders and owners a wide opportunity for expression of their creative impulses," Olivieri wrote in his study. North Wildwood and Wildwood Crest have the most notable Queen Anne houses.

The middle class, wanting to mimic the high style of Queen Anne, added spindlework, turreted posts and other Victorian detailing to their otherwise basic homes to create Folk Victorian style. Folk Victorian could be recognized as a distinctly Wildwood style, because the city was always a blue-collar vacation destination. Another option for middle-class homeowners seeking Victorian was shingle style, featuring the asymmetry of Queen Anne without the extreme ornamentation. In the 1910s, the Wildwoods looked like Victorian Cape May does today.

From the early 1900s to late 1920s, the bungalows of the Wildwoods were built in the Prairie and Craftsman styles that descended from the Arts and Crafts Movement. These simpler vernacular designs, characterized by low-pitched roofs, short, square columns and horizontal emphasis, became popular as Americans returned to favoring traditional building methods. West Wildwood had the largest concentration of Arts and Crafts bungalows and cottages. The quiet, low-lying borough of 700 year-round residents was established after marshland was filled-in to the south of Grassy Sound in 1920, when Craftsman style was at its peak. However, many original houses in West Wildwood were washed away in storms.

In the early years, the Wildwoods were a vernacular architectural treasure. Victorian homes were decorated, quaint Arts and Crafts homes were clapboarded, and grand hotels with towers and ballrooms lined the beach. But as these places aged over the decades, many became rundown and outdated. And with each building boom brought by the nation's economy swinging back into the black, the Wildwoods' founding dwellings were slowly destroyed. Repairing an old house is generally more expensive than ripping it down and replacing it, residents said, and it doesn't help that people with the skills required to fix old buildings are growing rare and their services more expensive. Residents here just didn't have the disposable income to pay for repairs, some said.

The postwar boom brought doo-wop architecture and motels, which have grown to be an iconic part of the island's identity; they replaced the hotels of old. A mid-1960s locally sponsored and federally aided "urban renewal" project wiped away what it deemed "blight": old hotels and mom-and-pop Pacific Avenue shops in favor of parking lots and storefronts without upper-level living quarters. But even that was not as severe as the mid-2000s construction boom that wiped away historic houses and doo-wop motels alike. Instead of the restorations and renovations houses needed at a tender age, many got the wrecking ball. Some were in deteriorated condition, but even houses in sound shape were lost forever because condominium units were selling for so much more than they were worth—it didn't matter how much old buildings cost to buy and knock down. In 2011, the late Janet Brown, the owner of the oldest house in the Wildwoods (see it on page 54), told *Shore News Today*, "The sun doesn't come in anymore because the condominiums are so high. Is that progress?"

It was a perfect storm: more people were buying second homes since, in the mid-2000s economy, no one needed excellent credit to get mortgages. Plus, the Wildwoods were being

discovered by North Jersey and New York vacationers as an affordable beach town in which to own a second home, according to a 2005 *New York Times* article headlined, "A Wildwood Makeover." The influx happened too fast for the island: the housing that was built was designed looked attractive on an online real estate listing to people who valued the indoors more than the outdoors, residents said. That involved building homes from the inside out, no matter how they looked from the outside or how strongly they were built. Tim Carter, a *Washington Post* columnist with decades of building experience, wrote in 2017 that most modern timber comes from light wood that is susceptible to rot, modern walls are thin enough to be depressed by a finger, and PVC pipes are not soundproof and fireproof as cast iron pipes were in early buildings:

> Back then, many workers considered what they did a vocation. They made it a career choice and took pride in what they did. Today, it seems that many workers treat what they do each day as a job. There's a vast difference between a vocation and a job ... The ever-rising standard of living here in the United States has put intense pressure on trying to keep the labor costs of building in check. Regulations, laws, benefit packages and other things that didn't exist 100 years ago add to the cost of building. To keep a job affordable, something has to give. You can imagine what that might be.

Most units built in the Wildwoods during the building boom would soon be in foreclosure because their buyers couldn't pay their mortgages, residents said. The housing bubble burst in 2007, and the Great Recession resulted in rows upon rows of vacant condo units, residents recalled.

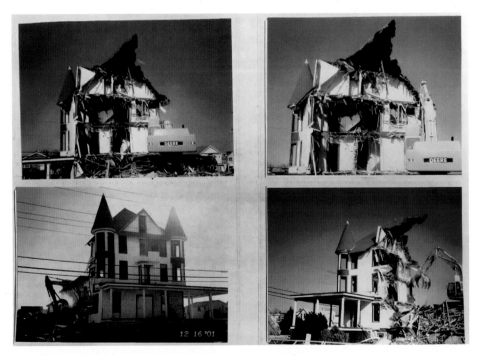

An authentic Victorian hotel, the Ocean Crest, was demolished for "modern Victorian" condos in Wildwood Crest during the 2000s boom. *(WHS)*

8

There weren't groups rallying for preservation of early buildings, like the Cape May citizens who saved the Emlen Physick Estate and ultimately formed the preservationist Mid-Atlantic Center for the Arts and Humanities in 1970. Before the building boom, a Wildwood Historic Preservation Commission (HPC) formed in 1997 in response to Olivieri's study. The volunteer committee offered exterior design advice and discounts to contractors whose services were correct to architectural periods. Homeowners whose properties were in one of Olivieri's historic districts had access to these resources. But most importantly, the HPC had an advisory board that could offer its opinion on projects sent to the city planning board. They reviewed requested demolitions of—and additions to—historic buildings in those districts. The HPC did not last, likely because of a lack of means to enforce preservation, combined with hostility from property owners toward municipal influence over the aesthetics of their properties, locals said. The HPC disbanded shortly before the boom, and no similar groups were ever formed in the other municipalities on the island, aside from the Doo-Wop Preservation League, which focuses on mid-century modern architecture. With no historical protection stopping them, developers had few obstacles in knocking down any building they wanted.

Many of the houses in the residential historic districts survived and remain clustered close to the center of town. In some old neighborhoods, condos jut out to the sidewalk, but for the most part the center-city neighborhoods were not as heavily redeveloped as the oceanfront and bayfront. But, locals said, just because preservation didn't work in Wildwood in the late 1990s doesn't mean it couldn't work elsewhere on the island. If ever an HPC were to form again, the island's identity would need to be looked at realistically. The residents of Wildwood did not seem to appreciate exterior design restrictions like those protecting Cape May's Victorian architecture, locals said. However, the homes that have been here longer than anyone alive need protection, period. Preservation just needs to be done in a way that fits the needs of the Wildwoods.

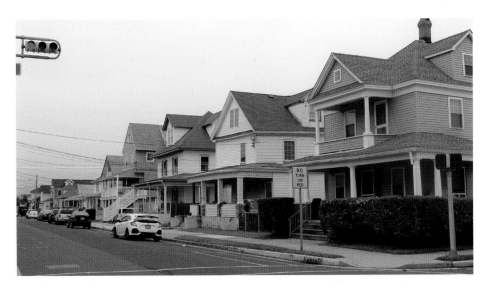

West Magnolia Avenue in Wildwood, lined with century-old homes, has remained mostly untouched by redevelopment.

Why protect these old houses? They are part of the Wildwoods' culture. They utilize architectural styles specialized for a class of American life, and they connect us to the people who established the Wildwoods. Many of the people who formerly lived in them were people who worked as straw and hay dealers, anglers, brick manufacturers and boardwalk storekeepers. Bankers, lawyers and doctors are not the only residents who deserve to be remembered, as the Wildwoods have always primarily been middle-class towns.

According to the homeowners who restored their homes, these houses were built with quality materials to withstand the harsh natural elements of a barrier island, as their continued existence proves. Because those materials came from local, natural resources, their reuse is more ecologically sustainable than demolition and new construction.

These houses remind us about America's rich past and what we did right. They attract people who care about the area, its history and its future. People who live in and fix up historic places are investing in the community and committing to being productive leaders of the neighborhood.

Plus, studies indicate historic places appeal to young homebuyers. According to a 2017 study "Millennials and Historic Preservation: A Deep Dive Into Attitudes and Values" conducted by Edge Research, ninety-seven percent of people born in the 1980s and 1990s value historic preservation. More than half view historic preservation as important to saving America's treasures for the future (fifty-seven percent), engaging in authentic experiences (fifty-two percent), and preserving a sense of community (fifty-two percent). As millennials become heads of households and homeowners, historic houses will likely become more valuable and neighborhoods will, too. Many of the houses in this book are being restored by young adults and their families.

Replacing old with new is a temporary solution to an age-old problem: old houses need updates and repairs. But these new buildings are going to have worse problems in a few decades: they'll be outdated, out of style and in need of structural repairs. In thirty years, are people going to be looking at shiny, white plastic railings and clean vinyl siding? Will these new buildings be top-of-the-line, desirable vacation destinations in a few decades? How long until they are looked at the same way most people look at wood paneling, shag carpeting and faux stucco today? Historic houses do not go out of style. What will be left of the island's culture if these temporary fixes continue to be used? This new construction is unlikely to last long enough to ever be considered historic, local tradespeople said, it will just continue the cycle of demolish and replace. Sturdy structures that have proven their longevity are being replaced with thin wood and flimsy siding that will not stand up to a half-century of hurricanes and nor'easters.

It happens in every growing shore town and city: as population increases, more housing is needed, and cheap building materials are proven to be the current standard. Wildwood's summer population expanded in the mid-2000s because it was the cheapest Jersey shore town at the time, but the unrestricted, rampant change that took hold was irresponsible and poorly planned.

Some cities turn to adaptive reuse to fulfill the demand for residential and business space. Adaptive reuse is the process of reusing an existing space for a purpose different to the purpose for which it was built. In the Wildwoods, some existing structures were converted

This historic Victorian house was demolished in favor of "modern" Victorian in 2017 in Wildwood Crest. *(WHS)*

to condo units or storefronts (see Chapter 3), allowing for preservation that meets the needs of residents today. The importance of preservation and adaptive reuse are explained by preservationist Nicole Curtis, host of HGTV's *Rehab Addict*. In her 2016 book, *Better Than New: Lessons I've Learned from Saving Old Homes*, she sums up what happened when corrupt redevelopment wiped away an historic mansion she tried to rescue in Minneapolis, Minnesota:

> with old houses, once they're gone, they're gone. All the handmade craftsmanship and greatness that we can't recreate ends up in a landfill. We were losing old houses by the dozens, and in the process, losing what made Minneapolis so unique to begin with. After all, one of the things that attracted me to the city was its beautiful architecture. As in so

many other cities, everything replacing the existing architecture for the sake of "density" (i.e., more housing) was what I call "disposable building." Nothing unique, nothing quality, nothing that would last a hundred years, and nothing anyone would marvel at if it did.

The Wildwoods' history is still at risk, even though the Great Recession halted the majority of redevelopment. In fall 2017, while summer residents were away, a 1900s Victorian home with a yard at 2310 New York Ave. in North Wildwood was demolished to make way for several single-family homes. Because of a rezoning measure that allows large lots to be divided into multiple lots with their own addresses, historic houses with spacious yards are most at risk. Also that fall, a pre-1940 turreted Tudor cottage on Sunset Lake at 6906 Park Blvd. in Wildwood Crest was sold and demolished in favor of something much bigger, taller and more expensive. In September 2018, one of the oldest houses in Wildwood came down: a cedar-shingled 1890s mansion at 116 East Poplar Avenue that was believed to be built by the Baker brothers, and which spent decades as the Rex Hotel. "It really is sad," Janet Brown told *The Press of Atlantic City* in 2007. "We look at garages instead of porches."

The Wildwoods still have hundreds of historic houses, and it's time they get the protection they deserve. Requests for demolition permits should be reviewed by HPC entities, and people who are rescuing the island's history by fixing up old houses or adaptively reusing places should be rewarded for the investment they are making into the island's future. Many cities offer tax credits to property owners who do this, thus attracting developers and homeowners who may be torn between repairing a place in the Wildwoods or in another town.

Additionally, there should be encouragement and incentives for people who maintain yards. Open space and foliage are becoming rare on an island that was, ironically, first settled in for its beautiful dense forests. Until yards are valued for the beauty they add to the neighborhood, they—and the houses they adorn—will merely be seen as potential for more tax ratables.

This book features a selection of the island's diverse architecture and quirky stories, but they are just a fraction of the hundreds of historic properties worthy of care. Thankfully, many homeowners are leading the way for preservation. Some are restoring their homes using historically accurate materials to bring their homes back to their former glories, and others are using modern renovation methods. Some bought their homes for their charm and character, others had their home passed down through generations. A few homeowners have incredibly meticulous documentation of the history of their properties, and others have discovered it through the research conducted for this book. Enough people care about the Wildwoods to prevent further loss of history. This book's goal is to bring those people together and prove the Wildwoods have something worth saving.

1

FOLK ARCHITECTURE

Most houses on Five Mile Island before 1940 were small or midsize wooden structures built by the first residents. Homeowners were usually blue-collar workers from Philadelphia and Camden who heard by advertisement or word of mouth of a prosperous new beach resort. They wanted to invest in land or build a summer home to get away from the stifling heat of the city.

A homeowner would buy a plot of land from an improvement company for a few hundred dollars. Corporations such as the Holly Beach Improvement Company, Wildwood Beach Improvement Company, North Wildwood Land Company or Wildwood Crest Company were made up of investors who bought tracts of land and turned them into towns. They laid out streets, divided the land into plots and sold the plots.

Deeds for these plots usually stipulated that houses be built within a year of purchase. Small cottages near the rear of properties were often built before the frontmost, larger houses because of the urgency of the one-year requirement. No cesspools were permitted, and nuisances such as the slaughtering of animals or boiling of bones were forbidden. Houses usually had to be built at least 10 feet back from the street and have flowers planted out front.

Some of these houses were moved from the sites where they were built. With few or no utility hookups or electrical wires hanging over streets, it was more feasible to move a house than to build a new one. Moving houses involved rolling them on logs while being pulled by horses.

From 1890s gothic, gingerbread-trimmed cottages to 1920s Craftsman bungalows, these traditional, simple abodes represent the middle-class Americans who built the Wildwoods.

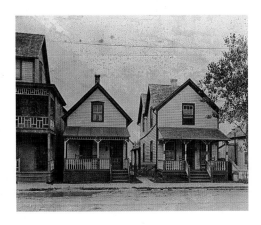

The home of William Shackleton, at left, still stands on East Rio Grande Avenue. *(WHS)*

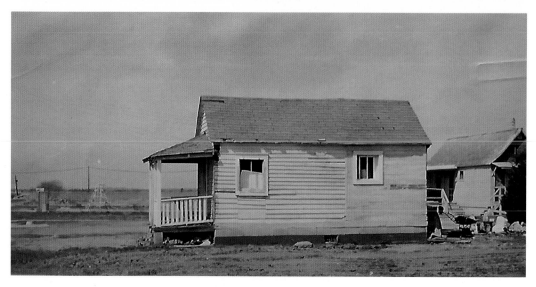

THE MINI HOUSE, HOLLY BEACH PARK, WILDWOOD: The first structure in Holly Beach was built in 1882 on Beach Avenue between present-day Taylor and Andrews avenues as the sales office of the Holly Beach City Improvement Company. A year later, Mary VanValin, the teenage daughter of first Holly Beach Mayor Franklin J. VanValin, used it as a schoolroom to educate settlers' children. When Holly Beach incorporated in 1885, the house served as borough hall, church and town meeting house. The Great Storm of 1889 washed away most of Holly Beach, but the Mini House was moved on a truck to Bennett and New Jersey avenues, and in 1950, to Taylor Avenue where Ridgway Moyers made it his home and later his toolshed. Moyers donated it to the city in 1975, when it was moved to Holly Beach Park and restored by Walter M. Gawel. Today it is cared for by Partners in Preservation. *(WHS)*

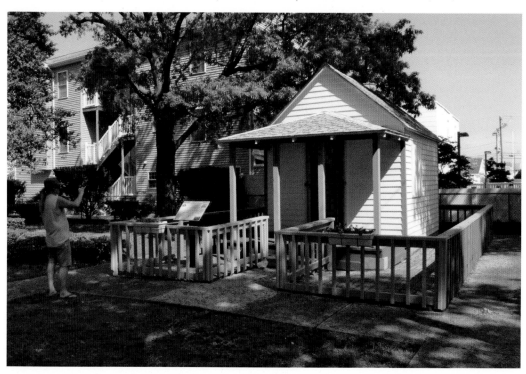

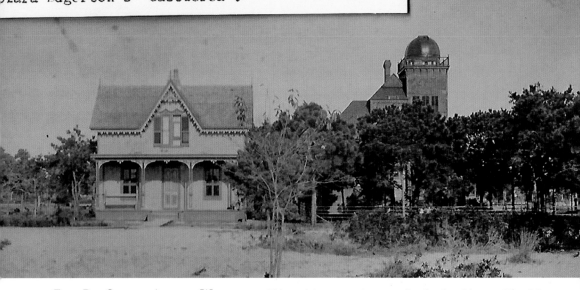

145 E. Rio Grande, domed house in background,
Clara Edgerton's "Castlerea".

EAST RIO GRANDE AVENUE, WILDWOOD: This gothic cottage is reputed to be the oldest residential house in Wildwood. It was built in 1884 in the Folk Victorian style that the English developed for cottages built in forests or countrysides. This cottage pre-dates Holly Beach by a year, and has a rare centered gable with pointed window in addition to pedimented windows. It not only survived the Great Storm of 1889, but it also survived arson in 1995. It had been abandoned for many years, but in 2017, a private owner bought it. In 2018, it was being renovated to become student housing. *(WHS)*

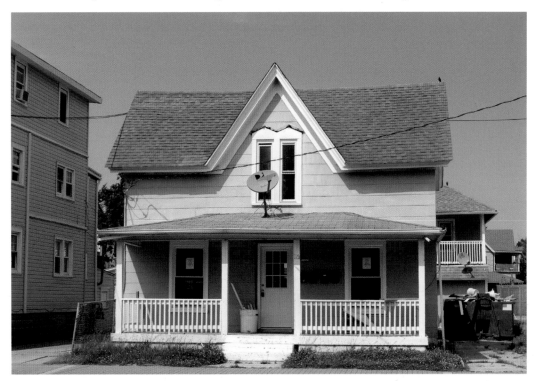

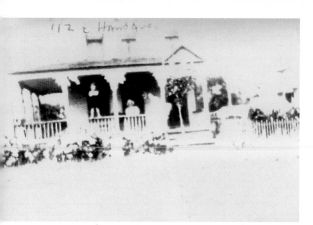
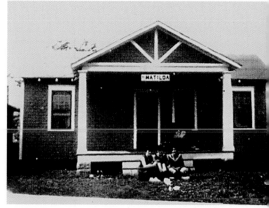

THE MATILDA, EAST HAND AVENUE, WILDWOOD: Built in 1886, a year after Holly Beach incorporated, this is one of the oldest houses in what is now Wildwood. Although it has no gingerbread, this gothic cottage is unmistakably Folk Victorian, and it still has its pedimented windows. It survived the Great Storm of 1889 (less than twenty houses did). In its early decades, it was the home of widow Matilda McGraw and her children Margaret Corr, a real estate broker, and Leo McGraw, a chauffeur. The rear cottage, which also still stands, was named The Matilda for the lady of the house. Rob Castor has owned it since 2000. *(WHS)*

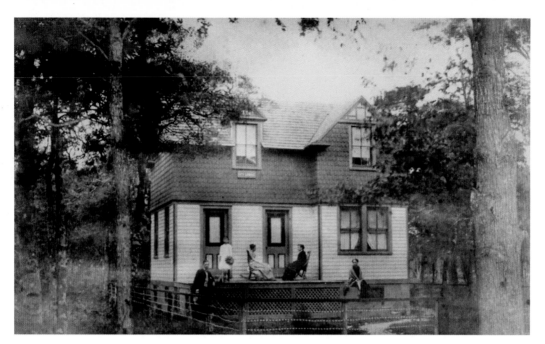

IVY LODGE, WEST LEAMING AVENUE, WILDWOOD: In 1890, Ivy Lodge was one of the earliest cottages built in the woods of Five Mile Beach. After its years as a beachside getaway, Ivy Lodge became the homestead of many families, including Philadelphia dentist Reginald G. Wilson and wife Laura; Italian-born machinist Louis Pittaluga and wife Angelina; World War II veteran Otto J. Fick and wife Hilda S.; and Ernest and Joan Troiano. Ernest's father Dominico emigrated from Italy in 1918, ending up settling on Leaming Avenue after he fell asleep on a train from Philadelphia to Atlantic City. Ernest became the second Italian on the fire department, and even designed the city's 1964 firehall. His widow Joan still lives in the house, which has gained two additions. *(WHS)*

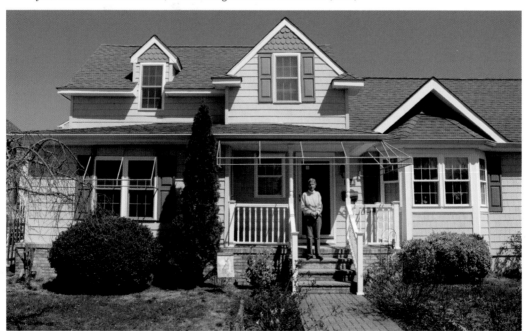

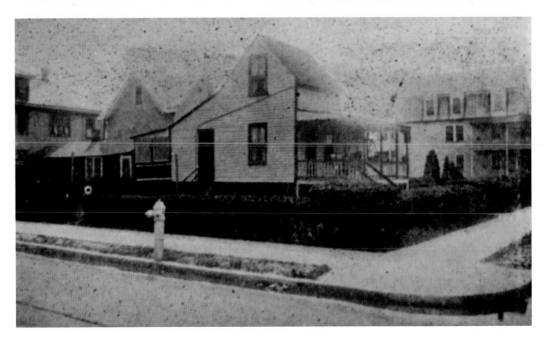

THE LANE PROPERTY, EAST LEAMING AVENUE, WILDWOOD: "Saltbox" is the nickname given to a house with a one-story addition built onto the side or back that extends the roofline. The name comes from its resemblance to the asymmetrical wooden box in which salt was kept. Saltbox houses originated in colonial New England, and are incredibly unusual in Wildwood. This cottage was built at the turn of the twentieth century, along with a repair shop in the backyard. Patrick and Elizabeth Lane were its original residents, but by 1925, it was listed for sale in a brochure that read, "This house can be easily removed" to build storefronts. The house stayed, and in 2018, received new siding and windows. *(WHS)*

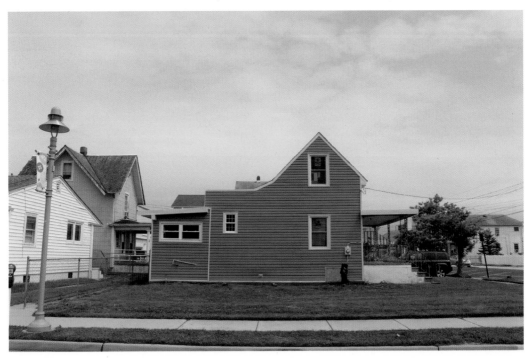

AARON C. ANDREW OCEAN LOOKOUT
HOUSE, EAST HAND AVENUE, WILDWOOD:
Aaron C. Andrew, the Holly Beach founder for
whom Andrew (now called Andrews) Avenue
is named, built this Folk Victorian around
1894 on Atlantic Avenue. Andrew first came
to the shore in 1880 after a doctor prescribed
his ill wife Sarah a healing trip to the beach.
Two years later, Andrew helped found the
Holly Beach Improvement Company. Atlantic
Avenue used to be steps from the ocean, so
this was Andrew's ocean-view home. Around
the turn of the twentieth century, the house
lost its ocean view when it was moved to Hand
Avenue, possibly in response to the Great
Storm of 1899. During the Great Depression,
Tess and Frank Bondira bought the house after
years of renting the neighboring cottage. Their
grandson, Andrew Yevish, inherited the house.

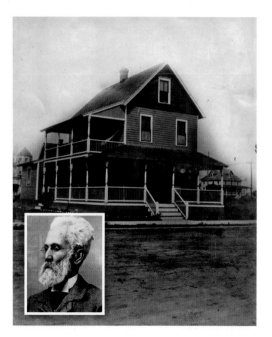

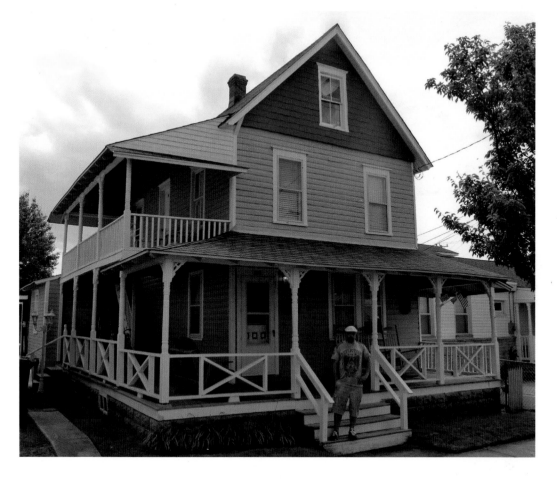

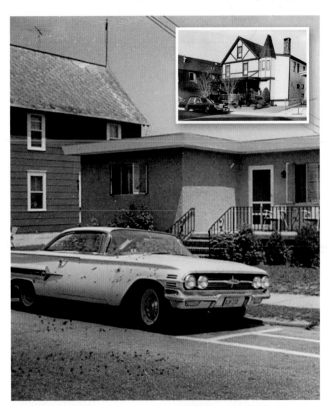

LAURIELLO RESIDENCE, EAST HAND AVENUE, WILDWOOD: The lot on which this 1897 house stands dates to 1882, when the Holly Beach Improvement Company sold it to one of its largest investors and the namesake of Montgomery Avenue, Thomas Montgomery. A house painter named Abraham Lincoln Samuels, born in Camden in 1865 (the year of President Lincoln's assassination), came to Holly Beach with wife Emma in the 1910s and bought the house. In 1967, Lenny Lauriello, a fireman and electrician, and his wife Lois, a councilwoman, moved in. Lenny always rode his bike down Hand to admire this house as a child. The tower, east wing and half-timbering were 1984 additions. Top photo shows changes between 1960 and 1997. *(WHS)*

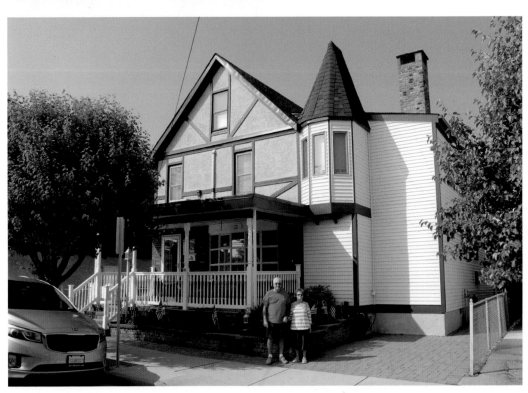

One Block to the
Beach and Boardwalk

The COLWYN

Central
All Ac

228 East Spencer Avenue Phone 5:

ROOMS AND APARTMENTS

All rooms are pleasant, airy, comfortable . .
cold water . . . Hollywood beds . . . restful rr
. . . daily maid service.

T.V. LOBBY

MOTEL ROOM ALSO AVAILABL

1-2-3 bedroom and bath apartments . . . Sle·
persons . . . All facilities are clean, modern.
able - - - Rates are modest - - - Located hea·
quiet yet within easy walking distance of
activities - - - Few feet to World's Best Be·

FREE PARKING

Helen and Leon Prynoski: Owner-Manag

1945

Off Season Rates Are Greatly Reduc

Reduced Rates Pre-season and After Lak·

THE COLWYN, EAST SPENCER AVENUE, WILDWOOD: William R. Neill was born in Northern Ireland in 1879, immigrating to America in 1905 to work in plumbing and heating. He married a Mary of Pennsylvania about a year later, and rented an apartment in Wildwood until they could afford this 1900s Victorian house. The Neills raised five children here, Doris, William Jr., Elizabeth, John and Edward. By the 1940s, the Neill home had been converted into apartments and named The Colwyn. It has been an apartment since, today as the Crescent Wind. Its tower, planters and porches keep its whimsical charm alive on a block that is bordered by stretches of mostly uninterrupted, vinyl-sided new construction. *(WHS)*

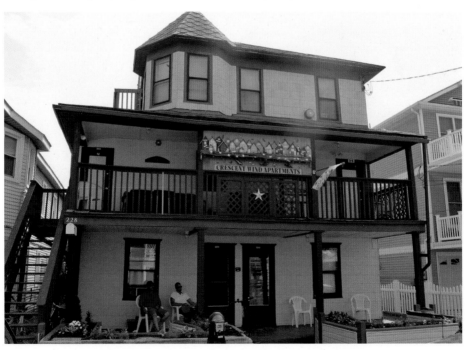

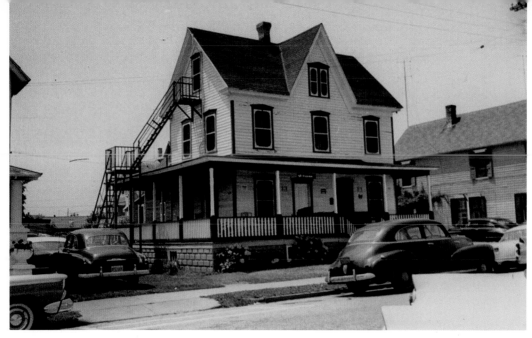

HOTEL RUDOLPH, EAST TAYLOR AVENUE, WILDWOOD: Button maker and shell importer Thomas Jones bought two adjacent lots from Holly Beach Improvement Company in 1884, and sold them to developer Mary Ober in 1894. This rare gothic cottage was allegedly moved on logs from Atlantic Avenue to this property, possibly due to the Great Storm of 1899. Ober sold both lots to butcher Edward Steblau in 1899, who ran them as Hotel Rudolph, named for his son Rudolph. After Edward's 1901 death, Rudolph sold the lots to separate owners. Virginia Haverstick was the longest resident of this house, from 1945-1988. Edward and Mary Marlin purchased it from her. Edward, a woodworker, built gingerbread onto the house that bears cutouts of marlins. *(WHS 1960)*

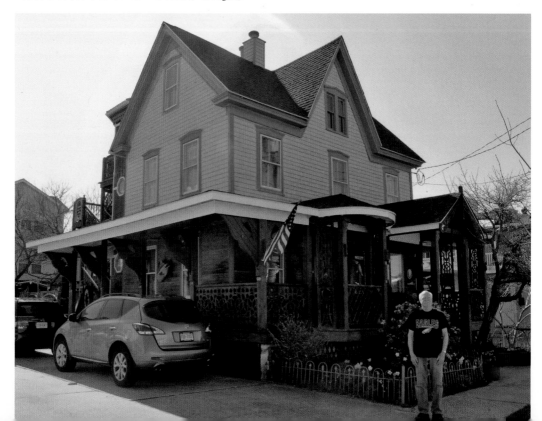

THE LARCHWOOD, EAST TAYLOR AVENUE, WILDWOOD: This is the neighboring property mentioned on the previous page. Company President Joseph Taylor, for whom Taylor Avenue was named, signed the deed for both properties to Thomas Jones. Jones built a cottage on this lot around 1890, and in 1894 sold both lots to Mary Ober. Henry Apeler, who bought this lot from Rudolph Steblau, built a Folk Victorian in front of the cottage in 1907. In the 1920s, John and Mary Carty operated it as the Larchwood Furnished Rooms, and in the 1950s it became the Anchor, enduring midcentury renovations. In 2018, Dennis Pierce, who always wanted to fix up an old house, bought it and began restoring it to its original glory. *(WHS 1960)*

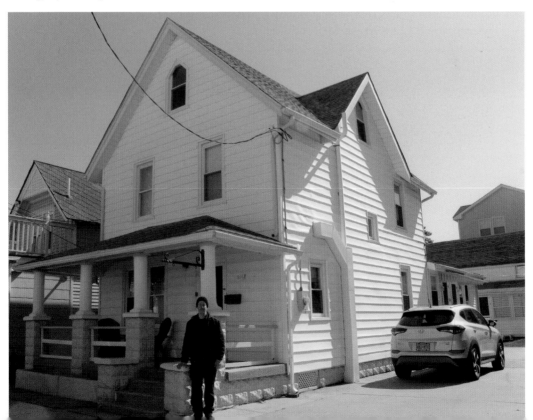

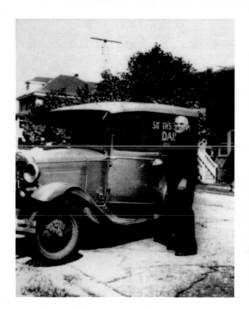 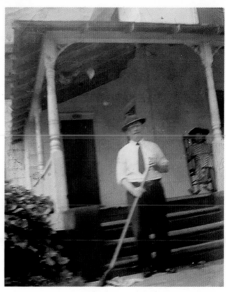

GANDOLFO HOUSE, EAST HILDRETH AVENUE, WILDWOOD: This Folk Victorian is an actual farmhouse. Leavitt (top left) and Anna Smith had a dairy farm at Hildreth and Pacific avenues since the 1900s. The Smiths had a barn with cows and distributed milk in trucks, and also sold ice cream. This was their house until 1921, when lawyer Harry B. Gandolfo (top right) and wife Marietta bought it from them. The Gandolfos and their four children came to Wildwood at the suggestion of a relative who spoke highly of the seashore's therapeutic effects on his health. The Smiths built a new house on the corner lot where the farm was, and continued to distribute dairy. The extended Gandolfo family has continued to enjoy the property as a summer home for three generations. After Harry and Marietta died, their son Augie became householder with his wife and three children. Augie's son Bob Gandolfo is the current owner. The home has never been renovated, as the Gandolfo family has always cared for the home and provided preventive maintenance. The dairy farm is now a parking lot.

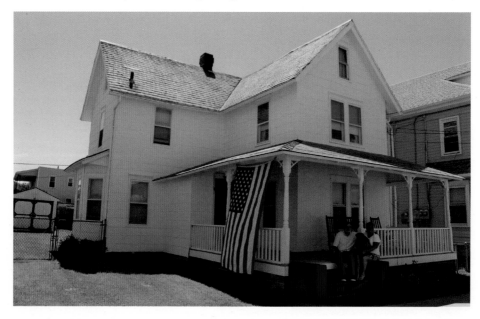

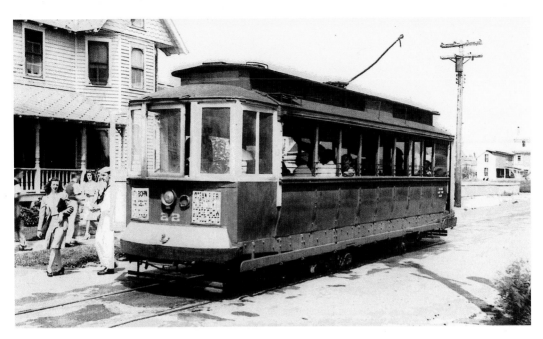

GAMON HOUSE, EAST BENNETT AVENUE, WILDWOOD: Thomas Gamon Jr. was born in Philadelphia in 1874 and served as chief clerk of the Federal Reserve Bank of Philadelphia. He and wife Lillie built their summer home, a Folk Victorian, in Holly Beach in 1902. He died in 1944 (a year after the above photo was taken), and this became the home of the Demski family. Monsignor Arthur Demski was pastor emeritus of St. Josaphat Parish, Bayside, N.Y. On two of the house's doors are etched glass windows depicting Niagara Falls, which were believed to have been installed by the Demskis. Since 2005, the home has belonged to Thomas and Judy Harrington. *(WHS)*

LONG'S MATERNITY HOME, EAST MONTGOMERY AVENUE, WILDWOOD: Hundreds of Wildwood citizens were born in this Folk Victorian house. Martin Long, born in Sweden in 1868, came to Holly Beach for fishing at the turn of the twentieth century. He became a wholesale test merchant at a fish processing plant. After his death, his wife Hattie supported herself as a maternity nurse starting in 1926. With the assistance of other doctors, she delivered 515 babies in this house well until the 1950s. By the late 1950s, she couldn't deliver babies anymore, so she rented furnished rooms. She died in the early 1960s. The only other maternity house on the island was run by Margaret Mace at 25th and Atlantic in North Wildwood. *(WHS 1960)*

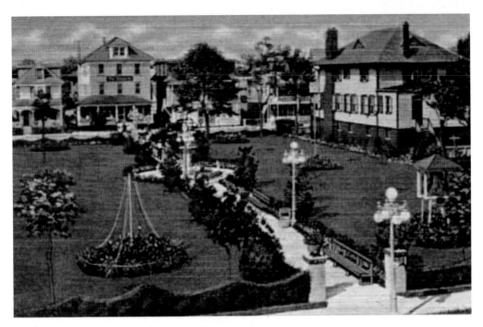

WELCH RESIDENCE, EAST ANDREWS AVENUE, WILDWOOD: Built in the 1900s next door to the post office and across from Holly Beach School, this Folk Victorian was once the center of town in Holly Beach. As Holly Beach consolidated with Wildwood in 1912, the post office and school were closed. The school became the site of Holly Beach Park during the Great Depression. In the early 1920s, the house was home to Pennsylvania Railroad Conductor George Mitchell and wife Hattie, followed by Hotel Pacific proprietor Jonathan James. His widow Hariett and their five children lived here for years after his death in the 1930s. Since 2002, the home has belonged to Bill and Linda Welch. *(WHS)*

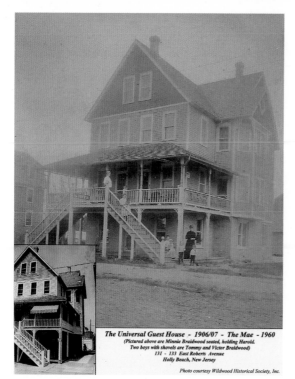

The Universal Guest House - 1906/07 - The Mae - 1960
*(Pictured above are Minnie Braidwood seated, holding Harold.
Two boys with shovels are Tommy and Victor Braidwood)*
*131 - 133 East Roberts Avenue
Holly Beach, New Jersey*

Photo courtesy Wildwood Historical Society, Inc.

UNIVERSAL GUEST HOUSE, EAST ROBERTS AVENUE, WILDWOOD: Victor and Minnie Braidwood married in 1899 and left Vineland to run a guest house in Holly Beach. Victor worked as a newsdealer and later ran a general store in North Wildwood while Minnie was landlady. Their sons Tommy and Victor were about six and four respectively in the above photo, and Harold was an infant. They moved to North Wildwood, and the Universal became a rooming house called The Mae. Eventually it was converted into apartments, but the gingerbread and clapboard siding are still true to the building's age. This block is one of few remaining that is lined with historic rooming houses. *(WHS)*

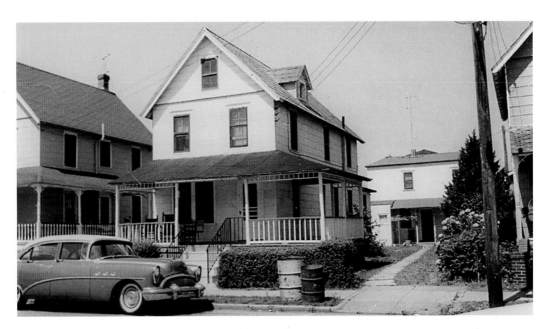

BOWMAN HOUSE, EAST DAVIS AVENUE, WILDWOOD: John C. Bowman, born in Saxony, Germany, in 1871, immigrated to America in 1893. He came to Holly Beach to work in the fishing industry, becoming a ship rigger and captaining his own boat. He also served on the Cape May County Fireman's Aid Association. With his income, John bought a lot and built a cottage at the turn of the twentieth century. He married Margaret Schmitt and had seven children: Albert, Carl, Frank, Gus, Henry Michael and Maria Anna. As their family grew, so did their property. In the 1900s, the Bowmans built a Folk Victorian house where John lived until his 1958 death. Later, the house was the summer home of the family of Wayne Aubrey, owner of the Monster Cone ice cream truck. In 2014, Ann and Hank Brandenberger made it their summer home. *(WHS 1960)*

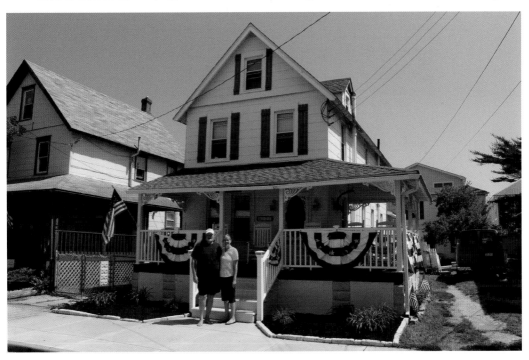

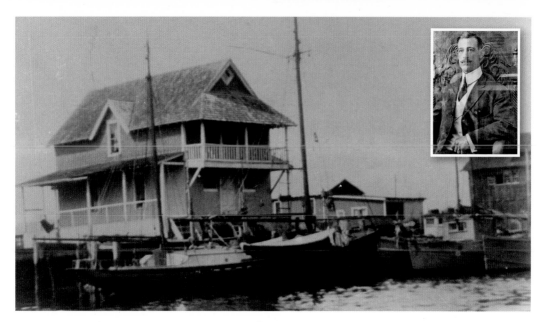

CHRISTIAN BERNSTEN HOUSE, TACONY ROAD, WILDWOOD: Christian Bernsten was born in Norway in 1879, and crossed the Atlantic Ocean on the Vaderland in 1901. Based in Brooklyn, he fished along the East Coast from Newfoundland to Florida. He came to Holly Beach for its bountiful fishing industry in 1907, where he captained the Anna Marie and Carib ships. He bought this tract of land from developer Henry Ottens in 1912. Ottens built the Ottens Canal, and fishermen like Bernsten settled along it for easy access to their boats. Bersten lived in this house for the rest of his life, at least until 1967. The house's foundation was damaged during Hurricane Sandy in 2012, and a new foundation was built. *(WHS)*

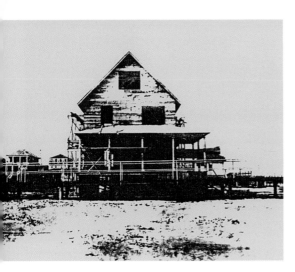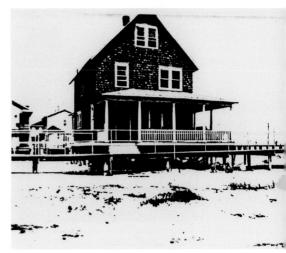

1913 BEACH HOUSE, EAST HILDRETH AVENUE, WILDWOOD: When this Craftsman house was built in 1913, it was directly on the beach. A boardwalk gave its residents immediate access to the ocean and main boardwalk. Children of the house enjoyed easy access to playing in the sand, shown in the above right photo. As the ocean receded and Ocean Avenue was built, the house lost its beachfront access. In the 1920s, it became the homestead of Rev. Adolph and Catharine Hellevige and their family. The home was restored decades later, and still has its original chestnut and maple woodwork, and quarter-sawn pine floors. *(WHS)*

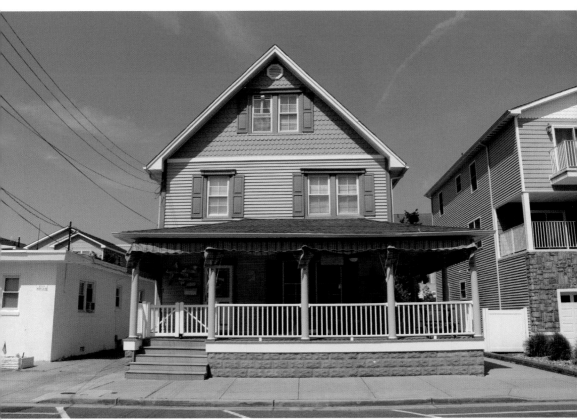

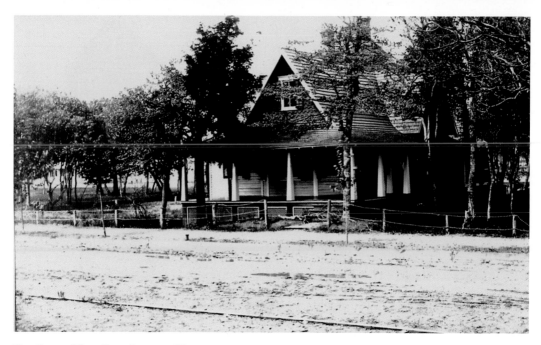

THE IDEAL, WEST PINE AVENUE, WILDWOOD: This cottage possibly dates to 1881. Pennsylvania teacher Stella M. Renn bought the land from Wildwood Beach Improvement Company in 1896 and lived there alone until she married Charles A. Lindemann in 1911. Ten years later, Stella sold the house to Ada and Carl Siebert. Carl died in 1924 and Ada passed in 1938. Both were buried at Cold Spring Presbyterian Cemetery. In 1957, Joseph Michael, a retired instrument worker at Philadelphia Naval Shipyard, his wife Eva and adult son John moved in. John still lives there and his grandson Johnny dedicates weekends to working on his favorite house, which still has a horse stable and yard full of holly trees. *(WHS)*

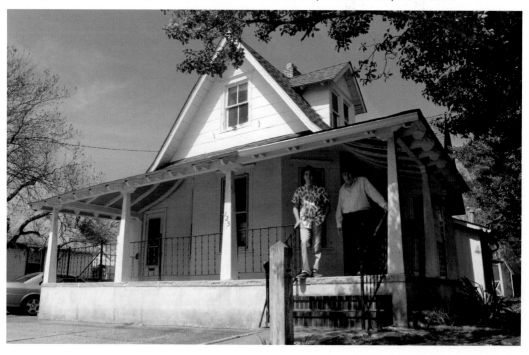

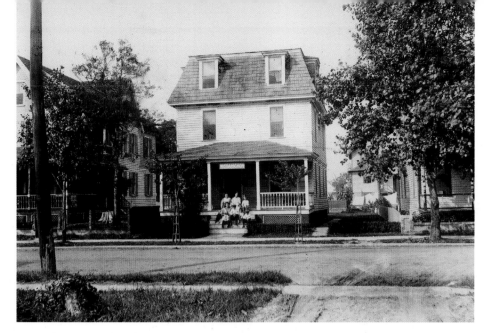

THE WISSAHICKON, WEST PINE AVENUE, WILDWOOD: One of the few Victorian Second Empire homes in Wildwood, the Wissahickon was a boarding house built in the 1890s or 1900s. It was the original site of the iconic "W" Tree, a wind-whipped tree featured in the city seal for 102 years. The tree was cut down and saved by the city during development. Boarding houses were important to the growth of Five Mile Island's economy, because they provided housing to construction laborers as well as a way for single women to support themselves as landladies. By the 1920s, landlady Mary Shinn converted it into apartments and renamed it Shinn Apartments. During its time as Harris Apartments in the 1960s, it was remodeled, and the facade and Mansard roof were hidden beneath a porch and balcony. *(WHS)*

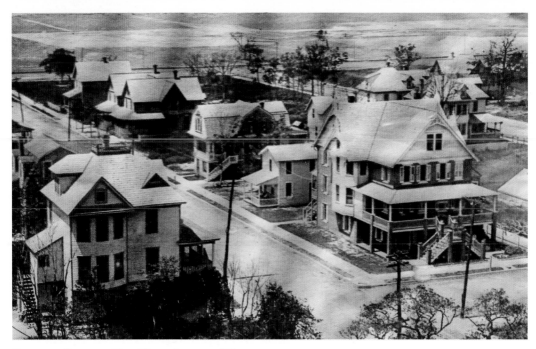

DUNHAM DUPLEX, NEW YORK AVENUE, WILDWOOD: Mason and bricklayer Albert S. Dunham, a native of Millville, was born in 1867. At the turn of the twentieth century, he purchased a lot in Wildwood and built a brick Folk Victorian duplex with his son Harry S. Dunham. Albert occupied one side and Harry the other. Together they operated Albert S. Dunham & Sons mason contracting company. The late Dunham's brickwork is still visible on the home today. The above photo was taken from the borough water tower. *(Above photo provided by Tom and Janet Felke)*

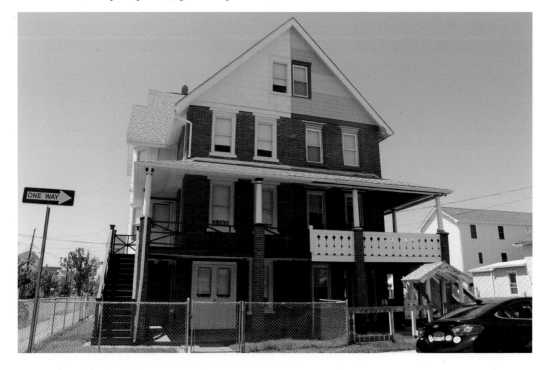

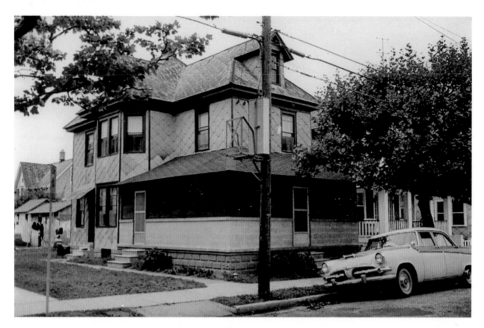

CHARLES SAUL RESIDENCE, WEST GLENWOOD AVENUE, WILDWOOD: Charles W. Saul was a notable businessman in Wildwood, making a living as a hay and feed merchant. When he came to Wildwood in the 1890s, he had a property with his name on it, literally: land was reserved for him when lots were first divided. Charles and wife Alida built a Folk Victorian house in 1899, with one-of-a-kind stained-glass windows. Charles served as Cape May County treasurer and freeholder, and was a member of the Wildwood Sinking Fund Commission before his death at age seventy-five. In 2003, Michael and Danielle DeMayo moved in after spending three years fixing up the house. The house's roof is visible in the 1900s photo on the previous page. *(WHS 1960)*

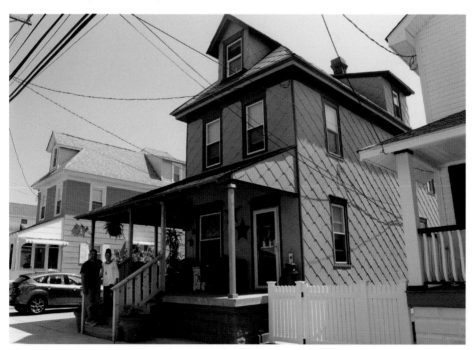

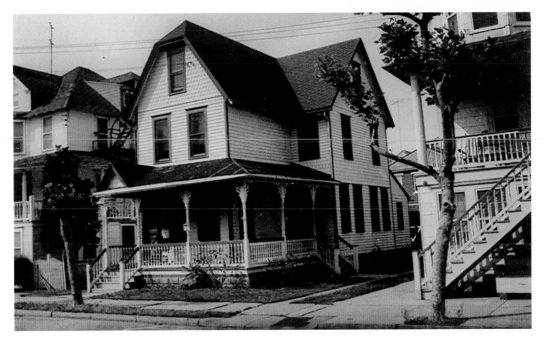

MCCLELLAND HOME, EAST MAPLE AVENUE, WILDWOOD: Vinyl siding and metal railings replaced clapboard and gingerbread, but this one-of-a-kind Folk Victorian has rare gothic form. Harry and Kate McClelland, born in Pennsylvania in the early 1850s, came to Wildwood at retirement age. They moved into this house, new in the 1900s, with their adult son, Harry Jr., born 1881. Living with them were H. W. and Kathryn R. Donaghy of Pennsylvania, and Mary Feely, a domestic laborer from Ireland. Meanwhile, Wally Burdalski Jr. grew up on the same street, two houses from the ocean. He went to the University of Pennsylvania, became a structural engineer and retired in Wildwood in 2003, buying the McClelland house. *(WHS 1960)*

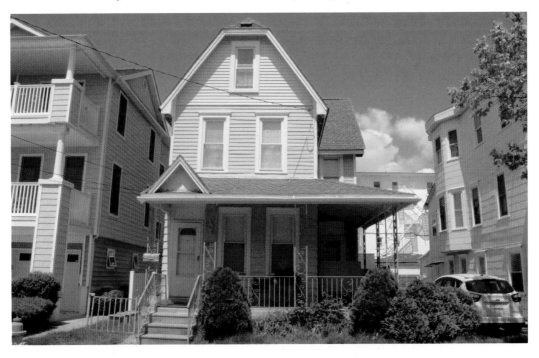

SHUTE COTTAGE, WEST POPLAR AVENUE, WILDWOOD: In 1895, this Folk Victorian was built for Theodore F. Shute, a general contractor in hauling, grading, and "cement work of all kinds" and a dealer in hay, straw, and feed. He lived on the bottom floor next to the horse stable and rented the seven bedrooms above. Shute Cottage offered vacationers a reception hall, parlor and sitting room whose cross-breezes cooled the house with fresh sea air. Realtor Thomas McCoy lived there next, followed by the Goodspeed family, who lived there for seventy-eight years. Debbie and Jim Sweeney bought it and began restorations in 2013. The house has enough bedrooms for their parents and all five of their children. "We're not condo people," Debbie said.

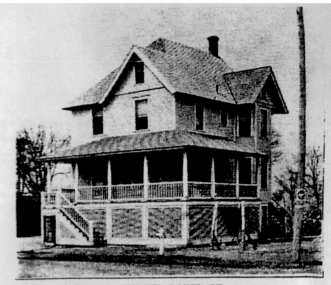

SHUTE COTTAGE
Poplar and Philadelphia Avenues. 2 squares from Beach.

Ground Floor Apartment–Occupied by Owner.
Upper Apartment, First Floor–Reception Hall, Parlor, Sitting Room, Dining Room and Kitchen.
Second Floor–4 Bed Rooms and Bath (complete).
Third Floor–2 Bed Rooms.
 For an afternoon siesta this Cottage affords all that can be desired

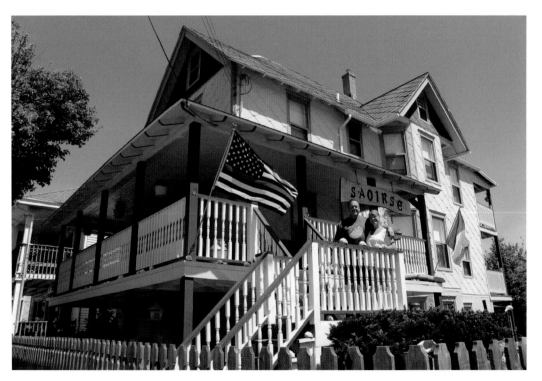

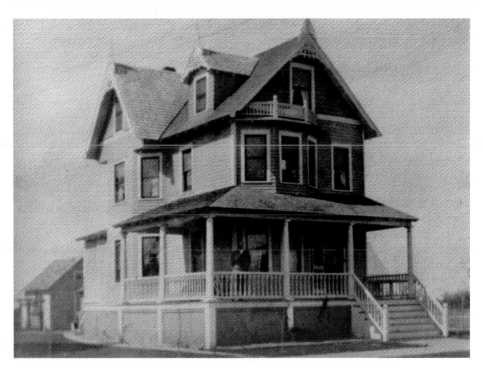

WOOD HOUSE, WEST JUNIPER AVENUE, WILDWOOD: This 1904 Folk Victorian has been in the Wood family for more than 110 years. The Baker brothers asked James Wood, a supervisor in their electrical plant in Vineland, to consider moving to Wildwood. Wood, his wife Annie and son Egbert moved to a house on New York Avenue in North Wildwood in 1907. After their second son, John, was born in the house in 1909, Annie asked James to move the house to Wildwood so they wouldn't have to pay tuition to send the boys to Wildwood High School. The house was moved about four blocks in 1912. In 1943, John inherited the house and renovated it. His daughter Virginia inherited it from him, and continues to renovate the family's heirloom.

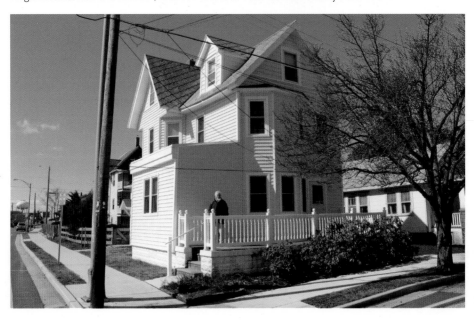

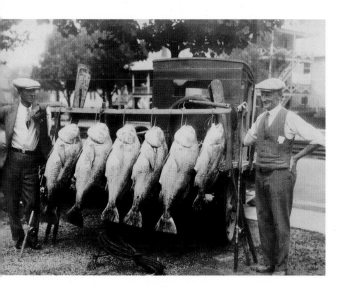

CHARLES GLENN RESIDENCE, NEW JERSEY AVENUE, WILDWOOD: Charles Glenn was born in West Virginia in 1880 and came to Wildwood during the development boom in 1900 to build houses. He built several hotels along the beach, was an expert drum fisher, and later became a state liquor inspector. During prohibition, he uncovered one of the "most unusual illicit alcohol stills" in New Jersey, according to a newspaper clipping. He built his family's house in the 1910s. On the North Wildwood beach, Glenn won the first race in aviation history between a motorcycle and a Wright biplane, which was piloted by Aviator George Gray. Charles was active in Tall Cedars, Masonic Lodges and North Wildwood Fire Company. His son Charles Jr. inherited the house and built a fish and tackle shop where their vegetable garden was. After Charles Jr.'s 1995 death, the house stayed in the family for another two decades. The top left photo shows Charles Sr. standing in the side yard with his fishing haul. The top right photo, provided by neighbor Virginia Wood, shows the house in the background. *(WHS)*

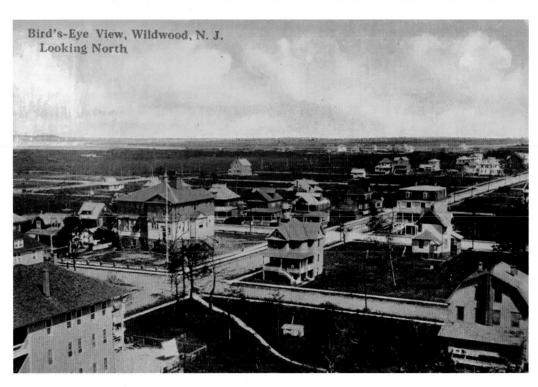

MANSARD DUPLEX, MAGNOLIA
AVENUE, WILDWOOD: This duplex is
a rare Victorian Second Empire, a style
popular in the mid- to late-1800s, before
Wildwood was a borough. It drew from
French building styles rather than English,
and its characteristics include mansard
roof, Italianate doorways and windows,
and square, symmetrical form. Few were
ever built on Five Mile Island, and even
fewer are left. For many decades, this was
the home of Joseph A. Borrell, his wife
Susan, and their son Edward J. Borrell,
an electrical contractor. At some point,
it may have been rented to fishermen, as
indicated by built-in desks on the second
floor. George and Ella Howarth lived here,
and today it is the summer home of their
children, Bernard and Diane Grill and their
children. (WHS)

DOLHANCRYK HOME, WEST POPLAR AVENUE, WILDWOOD: Built in the 1910s, this house exemplifies the vernacular transition from Folk Victorian to Prairie style. Dave Neff, who lived on Poplar his whole life, recalled a German couple living here. Charles Wehinger was a wallpaper hanger who didn't drive, so he pulled a handcart of wallpaper to his jobs. His wife Teckla baked excellent crumb cake, Neff said, and the couple played opera records loudly on Sundays. Later, the house was LeeDan's Guest House, a combination of the names of the owners, the Lees and D'Andreas. Marie and Pete D'Andrea were responsible for creating the St. Padre Pio Shrine in Landisville, N.J. Kenneth Drumm, a Skee-Ball manager at Hunt's Casino Pier, was the next resident. In 2016, the home was purchased by James and Josephine Dolhancryk, who renovated it. They plan to retire here. *(WHS 1960)*

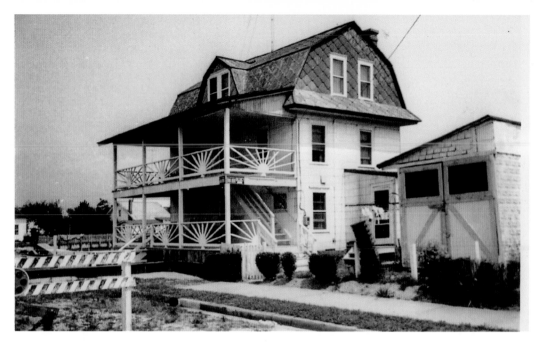

FRANCIS MARIE, WEST MAPLE AVENUE, WILDWOOD: In 1906, Pennsylvania Railroaders built this home as a summer retreat directly over Sunset Lake. It once had a ballroom and boat garage. Later the home was converted to a rooming house where sailors are believed to have stayed. For many decades, it was the summer home of the Kilpatrick family. During a powerful storm in the 1990s, flood waters lifted the house off its pilings and dropped it in the middle of the street, but movers put the house back on its foundation. Since 2017, it has been the summer home of Charles and Stephanie Starr of Franklinville. They named the house Francis Marie, for the combination of their late parents' middle names. *(WHS 1960)*

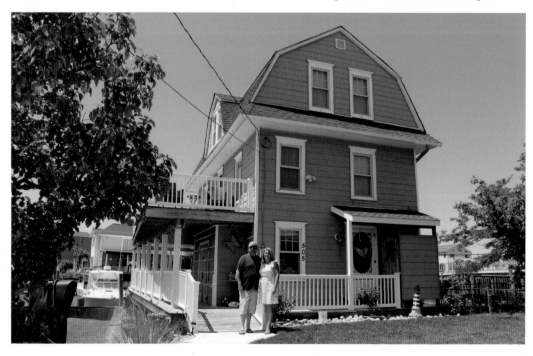

KREIN COTTAGE, HUDSON AVENUE, WILDWOOD: The Krein family has owned this *circa*-1913 cottage since 1919. Edward Krein, a plumber from Pennsylvania, and his wife, Mary, bought it as a summer home. The house was believed to have been built with small closets to avoid a tax on large closets. Their daughter, Grace Winifred Krein, married Ernest Bach in 1925 and the house was passed to them in 1945. Ernest died suddenly that year, but Grace lived here for four decades. It went from Grace to her children, and then to her grandson Edward E. Bach Jr. and his wife Deborah L. Bach. This otherwise shingle-style cottage was decorated with spindled woodwork to evoke the fashionable Folk Victorian style.

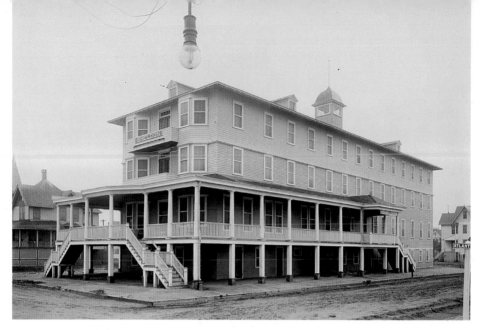

EAST MAGNOLIA AVENUE, WILDWOOD: Built by the Baker Brothers at the turn of the twentieth century, this style of Folk Victorian was a favorite for builders and middle-class residents alike. It was simple to build, and had the wraparound porch and bay windows vacationers sought. A house was built across the street in the same layout. Postal carrier Leo J. Kelly lived here with his family. The house was once a neighbor to the grand Hotel Sheldon, which is now a parking lot. In 2014, it was purchased by Judy Schwendiman and John Stewart, their son Dennis Christopher and his wife Kathryn Macaulay. During restorations, they found a glass flask from 1906 hidden in a wall. Dennis and Kathryn's niece Ryan Schwendiman, pictured, stays with them in summer.

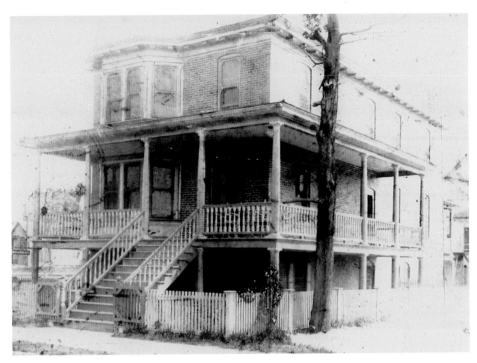

DELLI PAOLI RESIDENCE, WEST OAK AVENUE, WILDWOOD: A rare brick Victorian Italianate, this house was built *circa* 1910 for the Delli Paoli family. Extremely few Italianate buildings were constructed in the Wildwoods. Italianate structures are characterized by flat roofs, wide, overhanging eaves with ornate brackets, arched, paired windows and rectangular symmetry with side bay windows. Another brick Italianate with hipped roof and centered bay window stands on the 100 East block of Taylor Avenue. Frank and Congretta Delli Paoli raised six children in this home. After Frank died *circa* 1920, Congretta ran the home as a boarding house. *(WHS)*

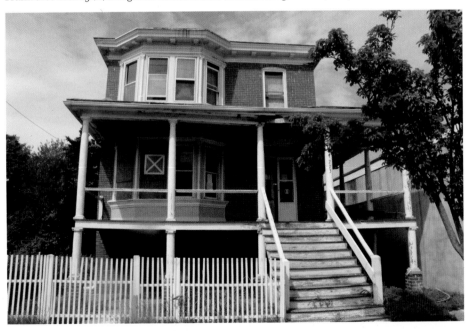

ADDIS VICTORIAN BUNGALOW, WEST PINE AVENUE, WILDWOOD: Built between the transition periods of Victorian and Craftsman in the 1910s, this bungalow has the ornamentation of the former style and the shape of the latter. It was built by a carpenter named Thomas Lower Addis, born in Pennsylvania in 1875, who came to Wildwood with wife Edna and their five children to make a living during the development boom. During World War I, he was drafted into service. Addis served in Co. K of the 320th Infantry Regiment, and returned from Antwerp, Belgium, on the USAT *Wheaton* in 1921. He resumed work for builder Warren C. Runyan, and died in 1954. Since 1963, this has been the home of Elizabeth Markee, who raised her children Billy, Linda and Michael here. *(WHS 1960)*

KLIMOWICZ BUNGALOW, EAST JUNIPER AVENUE, WILDWOOD: Twenties houses were all about simplicity and craftsmanship. This 1920s Prairie-style bungalow's quaintness still shows, although gingerbread has transformed it into a Folk Victorian cottage. It was first the summer home of bookkeeper Oakley H. Cropper and wife Bertha, then of Philip and Ruth Rosenberg who owned Sagel's Candies at Poplar and the Boardwalk in the 1940s. John A. and Toni Klimowicz of Delaware County, PA, moved in in 2015. John wanted a condo until he said his realtor told him condos aren't copacetic environments because not everyone contributes to the building's upkeep. Toni, who always wanted a Victorian house, fell in love with the cottage's gingerbread and porch. *(WHS 1960)*

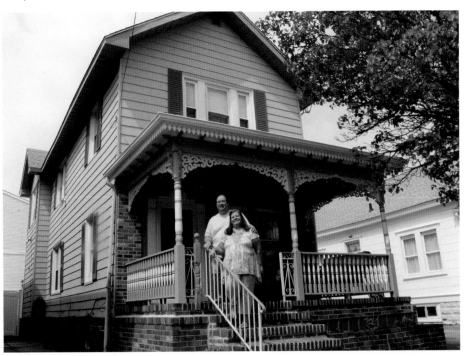

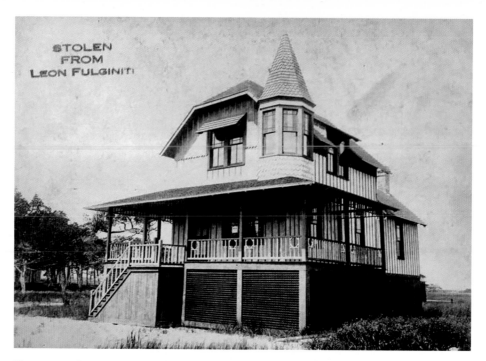

VICTORIAN COTTAGE, WEST OAK AVENUE, WILDWOOD: One of the earliest homes built in Wildwood borough, this gothic Victorian cottage was erected among the island's marshes and woods in the late 1890s. It was built beside the railroad that carried people from Wildwood Junction in Whitesboro, through present-day West Wildwood, to the Oak Avenue station that is now a Rite-Aid. Over its lifetime, it gained an addition, lost its stained-glass windows and was resided with asbestos. For many years, it was a rental. But in 2017, it was restored and painted a beautiful shade of plum. *(WHS)*

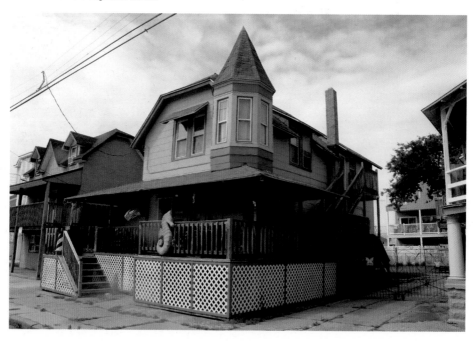

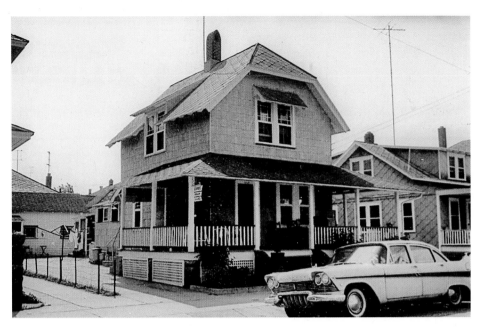

BANKS BUNGALOW, WEST PINE AVENUE, WILDWOOD: Sedgwood Rushing Banks was born in Salem County in 1869, the youngest of six children born to a boot maker. He married Jeanette Ritner in 1902 and they moved to Wildwood. Sedgwood worked as a gardener until World War I, in which he served as a chief boatswain's mate in the Navy. After he returned from war, the Banks moved into this 1910s Craftsman bungalow. It is an updated version of a Victorian blueprint nearly exact to the cottage on the previous page. Sedgwood died in 1951. Paul and Sally Tamberelli of Bergen County purchased it in 2018 as a second home. The Tamberellis used to own an 1890 house, and they bought this house because they "missed the feeling only a home this age can evoke." *(WHS 1960)*

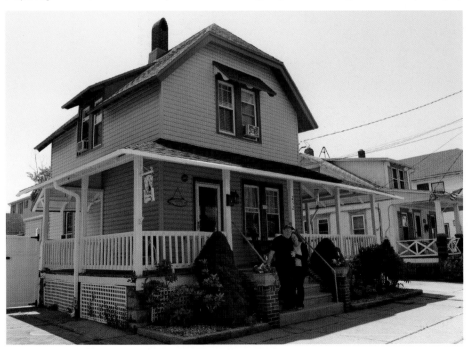

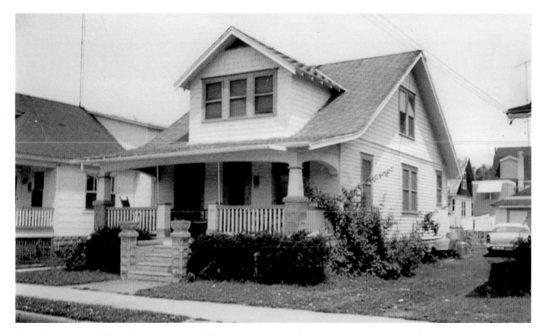

THE GLENMYRA, WEST PINE AVENUE, WILDWOOD: William C. Opfer, born 1900, grew up in Gloucester City. At age nineteen, he was an advertising writer, but soon got into the transportation business, supervising at Reading Transportation. William and wife Katharine began spending summers in Wildwood, where William worked at Yellow Cab Company and served as secretary/treasurer of Shore Service, Inc., a motorbus line. In the mid-1920s, The Opfers bought a plot and built a stylish Arts and Crafts bungalow. They lived there until William retired and they moved to Florida in 1952. Arthur M. Simpson moved in and named the bungalow Glenmyra, renting furnished rooms. In 1998, it became the homestead of Richard and Nilda Langston. This style of bungalow was built throughout the island. *(WHS 1960)*

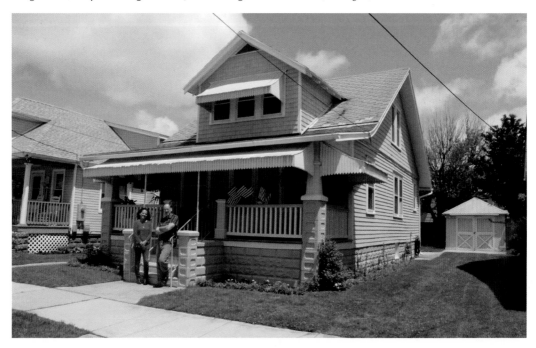

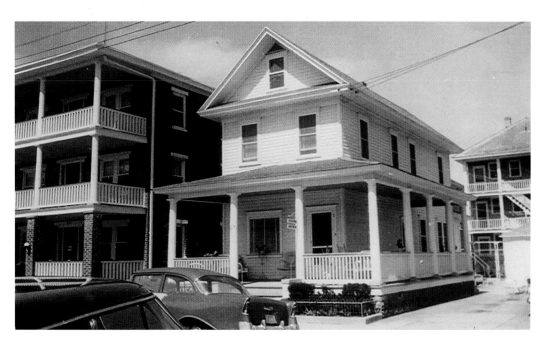

BRUNO HOUSE, EAST MAPLE AVENUE, WILDWOOD: Surrounded by 1920s houses, this Folk Victorian is older than the plot it is on. The land was deemed a property by the Baker Brothers in 1911–the year the boardwalk was moved closer to the ocean–but the house is distinctively 1900s. It was moved, believed to have come from a Baker Brothers building plant. After seven decades as a rental owned by the Salerno family, it was purchased by Eileen Collins. Collins used bricks salvaged from the Pacific Avenue pedestrian mall project to build a patio. John and Maria Bruno bought it in 2004 and restored it, keeping the original clapboard siding. "We truly love this home, and feel a true connection to it and the history of it," Maria said. *(WHS 1960)*

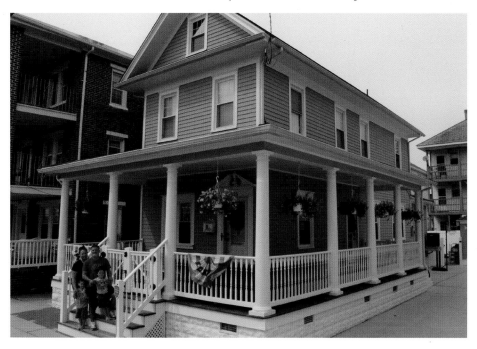

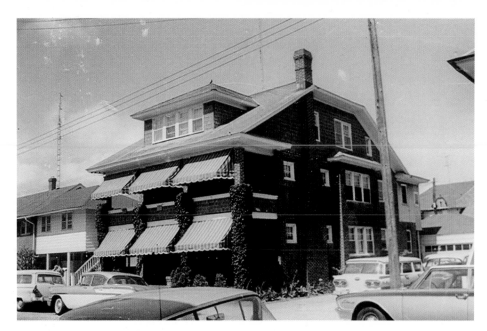

NEWTON HOUSE, EAST MAPLE AVENUE, WILDWOOD: On the same block as the previous house, this Craftsman duplex was built *circa* 1920 by Daniel Wade, who purchased the lot from the Baker Brothers in 1911. Although made of brick, it later became the home of a house carpenter, Frank Sheppard. Sheppard was one of many who came to Wildwood to make a living during the development boom. The house was passed to his daughter, Mary, who was a bookkeeper at Beecher-Kay Realty. In 2011, it became the home of Bert and Kelly DeSorte Newton, their children Bert Jr. and Kelsey, and their dog Lily. *(WHS 1960)*

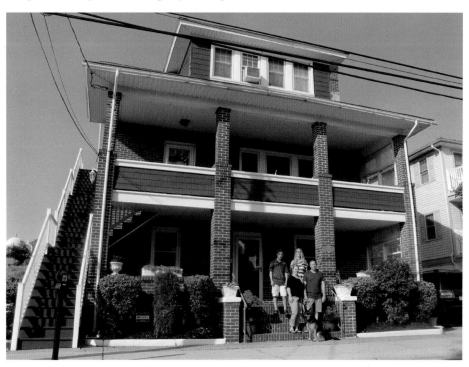

HILTON HOME, EAST MAPLE AVENUE,
WILDWOOD: Augustus Hilton was mayor when
Anglesea became North Wildwood in 1906,
serving from 1900 to 1908. After his term as
mayor, he managed a hotel in North Wildwood,
then owned Consolidated Fisheries and moved
into a new 1910s foursquare in Wildwood with
his second wife Alberta. Their son Frank's funeral
was held in the home in 1933, after his sudden
death in Montreal where he was head of a $5
million rum ring. Gus died in his home in 1948
and was buried in the United Methodist Church
cemetery in Pleasantville. Gus became a central
figure during North Wildwood's 2006 centennial,
when it was realized that famous hotelier
Conrad Hilton's father was named Augustus.
A "Where's Gus?" campaign was launched to
find a link between the Gus Hiltons. Conrad's
great-granddaughter Paris Hilton was invited
to the centennial, but the Gusses were never
connected. Also, in 2006, Hilton's house was
restored and converted to condos, one of which is
owned by Rich and Cathy Cassetti. *(WHS 1960)*

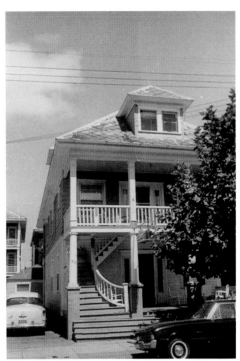

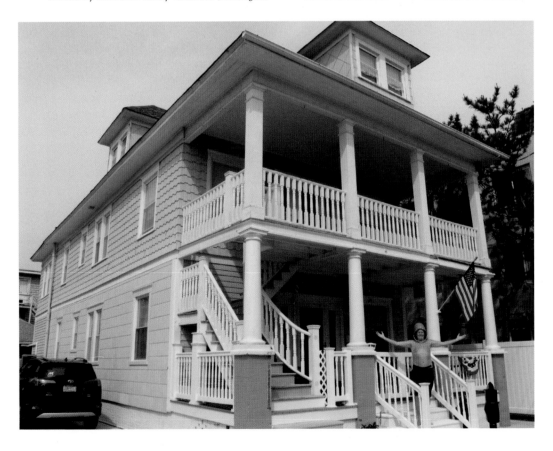

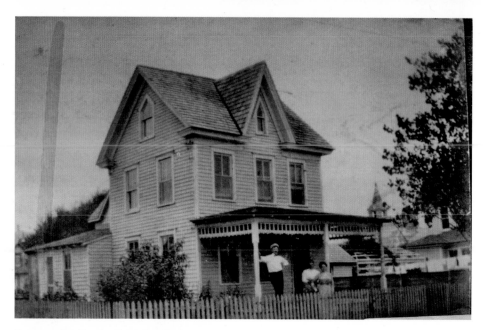

DREWES COTTAGE, EAST 1ST AVENUE, NORTH WILDWOOD: Constructed in 1875, this Gothic cottage is the oldest house in the Wildwoods. Charlie Drewes built it across from the one-year-old Hereford Inlet Lighthouse in the fishing village of Anglesea. Charlie's daughter Ella lived here for the rest of her life. It was passed from Ella to her cousin Pauline, and from Pauline to her son Larry Brown and his wife Janet. They kept the house's original furniture, potbelly stove and barn that once held chickens, cows and a horse. The house and its antique collection became local celebrities, garnering features in The Press of Atlantic City and Wildwood Leader. Janet lived here until she died in 2016 at age ninety-six. It is still in the family, now cared for by Charlie and Liz Maneval and Diana Brown.

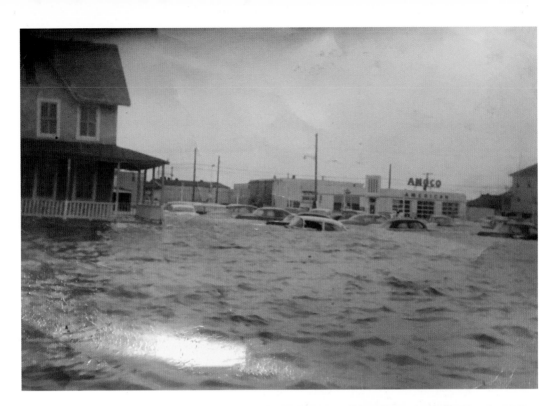

THE PORCH, WEST CHESTNUT AVENUE, NORTH WILDWOOD: Several early families who worked for North Wildwood lived in this turn-of-the-twentieth-century duplex. William C. B. Streaker, born in 1876 in Mount Holly, came to Anglesea to fish and work as sewer inspector. William and wife Cora had seven children. The Streakers shared the house with the Whildens. Roland F. Whilden co-owned Whilden and Dougherty fruit company with Miles Dougherty. Soon, Edmund Countiss Jr., assistant superintendent of streets and sanitation inspector, moved in with his wife Carrie, followed by another city employee, John Farry and wife Mary. Since 1984, it has been known as "The Porch," the home of Ed and Bunny Stewart and Bobbi and Bill Lehman. The top photo shows flooding after a 1964 hurricane. *(Top photo provided by Anglesea Pub, bottom photo provided by the Stewarts)*

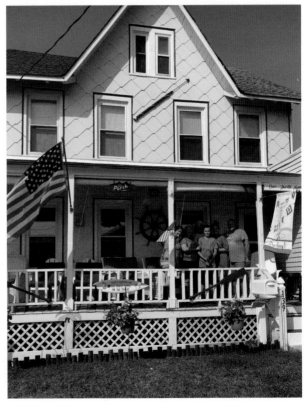

MAJESKI HOUSE, EAST 6TH AVENUE, NORTH WILDWOOD: Nathan B. Long immigrated from Sweden to work as a fisherman in Anglesea in the late-1800s, one of many Scandinavian men to establish a family in Anglesea. It is believed that Nathan built this gothic Victorian cottage around 1885 and it was the first on the block. Nathan and his wife Christina's son, Sven A. Long, served as assistant postmaster in Wildwood. In 1943, Joseph Majeski, a South Philadelphia restaurateur of Polish origin, purchased the cottage for $3,000 cash. He wanted a summer retreat for his two sons, Joseph and Vincent, who were returning from World War II. The house has stayed in the family for seven decades, and is now owned by the elder Joseph's grandson, Dr. Bernard Master, who is pictured with his wife Susan and their grandchildren. The top photo of Bernard on the porch was taken in 1947.

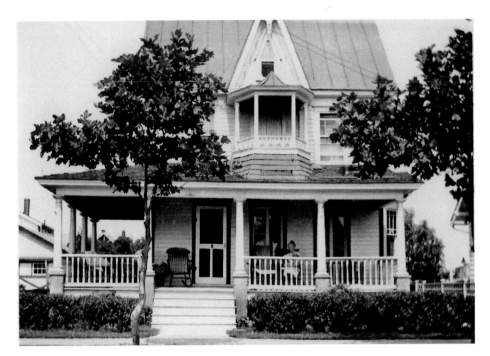

HELLER HOUSE, EAST 6TH AVENUE, NORTH WILDWOOD: Elmer Ellsworth Hewitt, named for the Union Civil War hero, was born in 1861 and grew up on a farm in Dyer's (now Dias) Creek. He became a house carpenter at Anglesea, building his gothic cottage by 1887. Ellsworth had served as Republican Inspector of Elections, tax assessor and councilman in the 1880s, and was part of the family that included first Hereford Inlet Lighthouse keeper Freeling Hewitt. Ellsworth died in 1932. In 1935, George and Annie (shown above in 1937) Heller visited a friend on 6th Avenue and mentioned they wanted to purchase a house at the shore. Their friend told them this house was for sale. The Hellers bought it, and it has been in the family since. Their grandson Frank and his wife Janet turned down purchase offers from developers and instead restored the home, where they still reside.

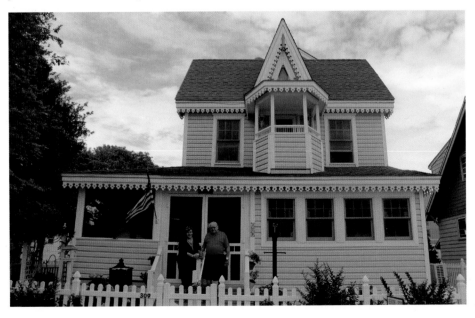

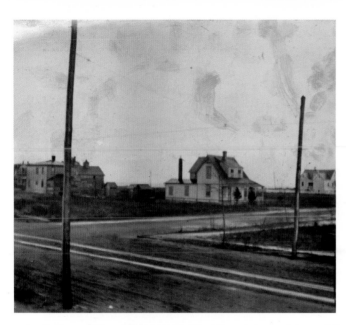

LORENZO SHIVERS' COTTAGE, EAST 2ND AVENUE, NORTH WILDWOOD: This 1895 angler's house with chestnut woodwork was purchased by steamboat captain Samuel Buck and wife Nora in 1901, when it was one of only a few on its block. It is the leftmost house in the above left photo. Samuel's nephew, fisherman Lorenzo Brown Shivers and his wife Georgia Rena, bought it from the Bucks in 1919. Lorenzo met Georgia Rena on a ferry between Anglesea and Stone Harbor. She, a well-dressed Philadelphian, was cold, so he, a mechanic, lent her his stained workcoat. He proposed within days. Their daughter Marion Shivers Mouklas has lived in the house since she was born in 1921. The Shivers were ancestrally fishermen and boatbuilders descended from Thomas Cheevers, who left Ireland for Virginia Colony in the 1600s. John Howland, who came to America on the *Mayflower*, is another ancestor. They are distantly related to first Hereford Lighthouse keeper Freeling Hysen Hewitt.

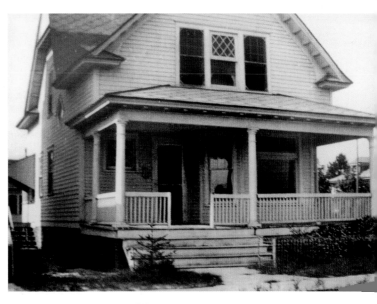

JOSHUA SHIVERS' HOUSE, THIRD AND ATLANTIC, NORTH WILDWOOD: Joshua Stites Shivers, brother of Lorenzo Shivers on the previous page, was born in 1876, the son of Edward M. and Cornelia Shivers (their house on page 85). Joshua came to Anglesea for fishing, and built his Folk Victorian house in 1904 next to his parents' house. Joshua was captain of the steamboat *Lillie*, which he operated both as a fishing vessel and party boat during different times of year. Party boats allowed vacationers to try fishing. Joshua lived here until his 1960 death. In 2014, Joe and Barbara Ems restored the house, keeping its original windows and clapboard siding. They replaced a later brick porch with a wooden porch almost identical to the house's original porch.

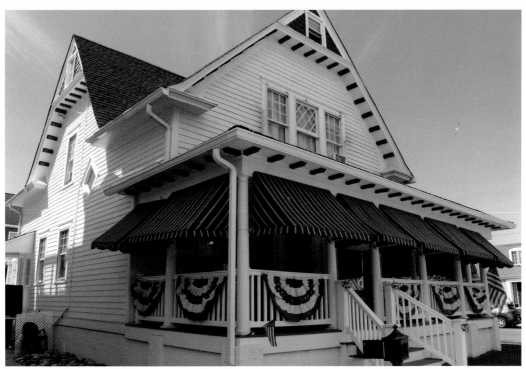

114 W. 24th---1904

116 W. 24th---1904

, N. J., WEDNESDAY, AUGUST 24, 1904.

t Public Sale

Holly Beach Properties

:man & Co., Auctioneers, on

PAVILION

Monday, August 29, 1904

/ Will be Sold to the Highest Bidder

Numbers 2 and 3

Number 2 is Located on 24th Street. Number 3 is Located on 24th Street

Number 2 Cottage. Located on 24th Street. Lot 28, Block 165, and contains all of the conveniences as outlined in No. 1

Number 3 Cottage. Located on 24th Street. Lot 29, Block 165, and contains all of the conveniences as outlined in No. 1

LOTS IN HOLLY BEACH

No. 1, lots No. 29 and 30, block 163 on Roberts avenue and Atlantic avenues, 40x100, 50x100, containing 50 ft. on Roberts and 100 ft. on Atlantic ave., will be valuable as a cottage property, in view of Board Walk going up next year as it will double in value.

No. 2, 3 lots on Spicer ave., No. 24, 25 26, block 128, lots 40x100, 120 ft. front by 100 ft. deep, one of the best locations on beach front only 3 squares from Wildwood and near ocean front.

No. 3, 7 lots on Young ave., No. 8, 9, 10, 11, 12, 13, 14, all lots 40x100 ft. or 280 ft. on Young ave., by 100 ft. deep, high ground, grand site for hotel, being on beach front and 5 squares from Wildwood.

Minnesota Cottage, lot No. 2, block No. 48, Holly Beach, N. J., lot 40x100, North side Rio Grande avenue, east of Pacific, cottage has 8 rooms furnished, electric lights, city water, cement pavement and curb.

Lucile cottage, lot 18, block 98, Holly Beach, N. J., lot 40x100, north side Hand avenue, west of Holly Beach avenue, has 6 rooms furnished, city water.

COTTAGES 2 AND 3, WEST 24TH AVENUE, NORTH WILDWOOD: Once surrounded by trees instead of houses, these twin cottages were the first built on the block in 1904. They were auctioned off that August, and have since witnessed the empty block fill with houses, the town name change from Anglesea to North Wildwood, and the construction of the North Wildwood boardwalk. The westernmost cottage has been in the Mormello family since 1957, being passed down to painter Walter Mormello and his wife Patricia in 1990. The Mormello house is now slightly taller than its twin, as the Mormellos had its foundation raised a foot. *(WHS)*

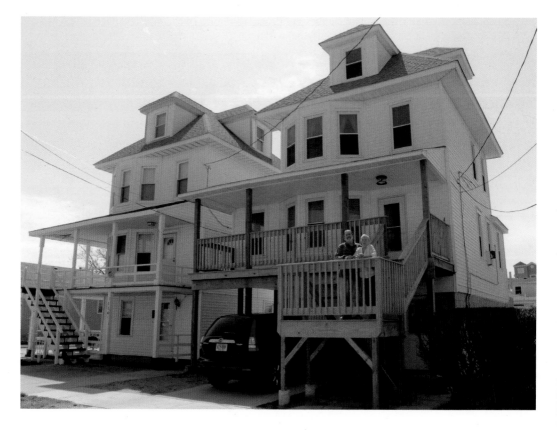

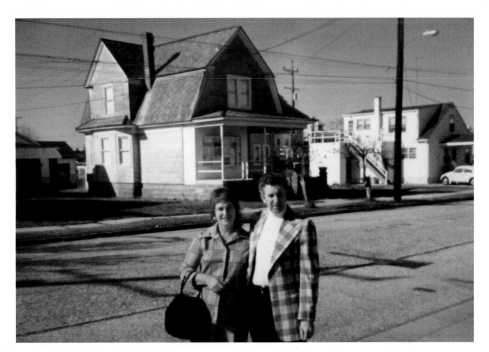

O'BRIEN HOUSE, WEST 4TH AVENUE, NORTH WILDWOOD: This Folk Victorian house was built in the Shingle style popular in the 1900s. Shingle marked the transition period from Victorian to Prairie style. From Queen Anne, this style borrowed asymmetry, and from Colonial, it borrowed the gambrel roof. This house was built *circa* 1906, the only house on its block besides the two on the previous page. Its shingles were covered by vinyl siding, but it still has its iconic shape. For decades, it was the summer home of the Sullivans of Erdenheim, PA. It was purchased in 1972 by Nancy and Chuck O'Brien, who lived across the street and needed a larger home for their growing family. Chuck worked in the Philadelphia Navy Yard. Nancy still lives here today.

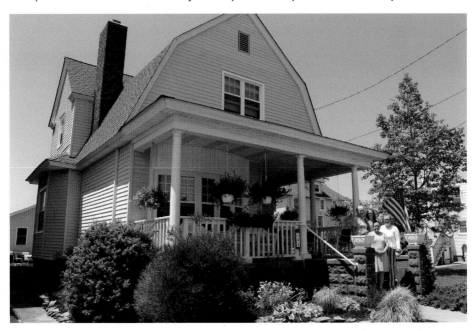

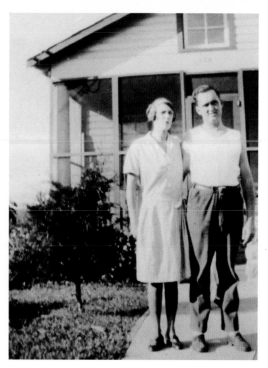

STEVENSON BUNGALOW, EAST 6TH AVENUE, NORTH WILDWOOD: This 1920s bungalow has been the summer home of the same family for about 100 years. John Stevenson, a vegetable cart vendor and gambler, had settlement with King Realty in 1922. Family lore says this house was once a post office at a local military base that was moved and converted into a residence. On the walls are lines from where a partition may have once been. John died after he was shot in the head at a card game. The bungalow was passed down to his son Bill and his wife Ella, then to their son Richard, who left it to his nephew John and niece Carol. It is still owned by John and Fran Stevenson, and Carol's children Dana, Evan and Darryl Pellegrino. This small bungalow has strong craftsmanship, as evident in its genuine wood-panelled walls and ceilings.

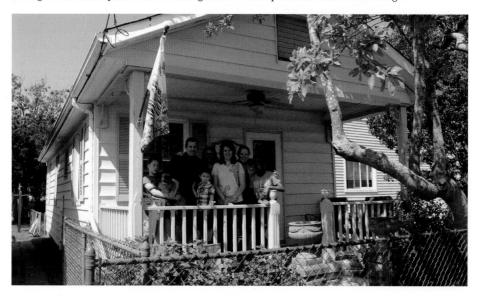

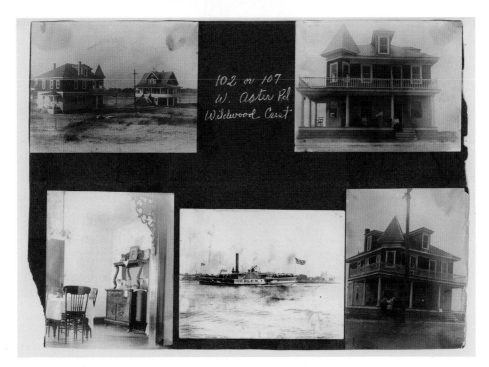

THE ASTER, WEST ASTER ROAD, WILDWOOD CREST: Built in the 1900s, this was the first house on its block. Like many Wildwood Crest houses, it was built during the transition period from Victorian to Craftsman, so it has elements of both. Other than the Victorian corner tower, the form is American Foursquare. Nicknamed The Aster, it was believed to have been built by house carpenter James Voshell. James and wife Bertha lived here until the mid-1920s, when they moved in with their daughter and her husband on Pacific Avenue. The next resident was music teacher Frank Neumann. *(WHS)*

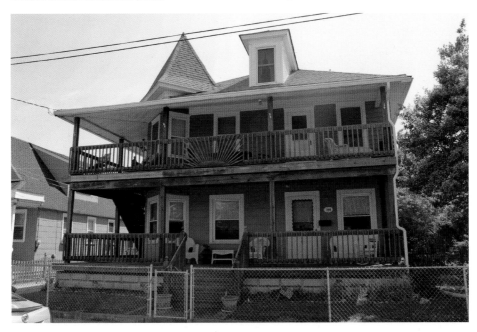

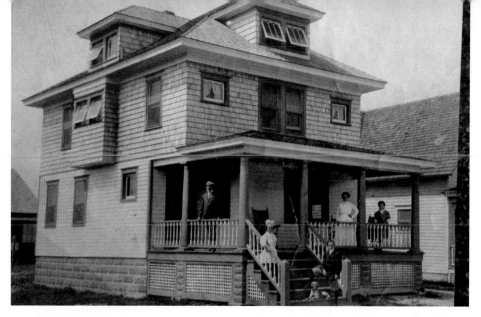

KOLB HOUSE, WEST LAVENDER ROAD, WILDWOOD CREST: This Foursquare was built *circa* 1910 on Philip Baker land. Baker was a founding Wildwoods developer and the first mayor of Wildwood Crest. The Wildwood Crest Corporation sold the plot to brick manufacturer William Kolb with the requirement that he build a house on it within one year. In 2015, retired Crest Police Officer Jim Bradley and his family became the house's third owners when he bought it at estate sale. He converted the house back to a single-family home from two apartments; the previous owners had divorced and divided the house into separate quarters. The house is a classic example of the island's prevalent Craftsman architectural style, when Victorianism lost popularity around the same time as the Crest's 1910 incorporation.

2

GRAND HOMESTEADS

Cape May is not the only Jersey shore town with rich Victorian architecture. Notables of the Wildwoods designed stunning Queen Anne and Neoclassical homes for their families. Doctors, lawyers, bankers, politicians and religious leaders commissioned expansive homes with brick fireplaces, vestibules, parlors, dining rooms, vast kitchens, abundant bedrooms and servants' quarters with separate staircases. To sound quaint, owners called their homes "cottages."

As original homeowners died off, many houses were subdivided into rooming houses because of the large amout of bedrooms. Several homes in this chapter still have numbers on bedroom doors.

Rooming houses were tied to women's history in the Wildwoods, because being a landlady was one of the few careers acceptable for a woman before the 1950s. Most landladies were widowed, their husbands killed in war or industrial labor, or lost at sea. Widows were forced to support themselves, and housing was needed as the Wildwoods developed. People who stayed in rooming houses were—ironically—men in the same line of work as the landladies' dead husbands. They were injured soldiers sent by doctors to the shore to heal, construction workers developing the island, and traveling fishermen. Landladies cooked food, washed clothes and provided beds for these men who were far away from their wives and permanent homes.

Today, families are restoring many of these architectural gems. Some are bed and breakfasts, some are homes for families with lots of relatives, and some are rooming houses to this day. Yet others are boarded up, waiting for someone who sees the beauty and history beneath the asbestos shingles and distorting additions.

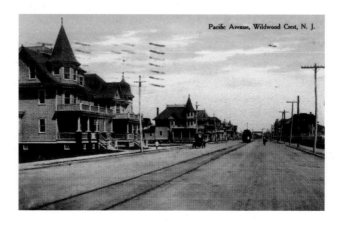

These grand Victorians still stand on Pacific Avenue in Wildwood Crest. (WHS)

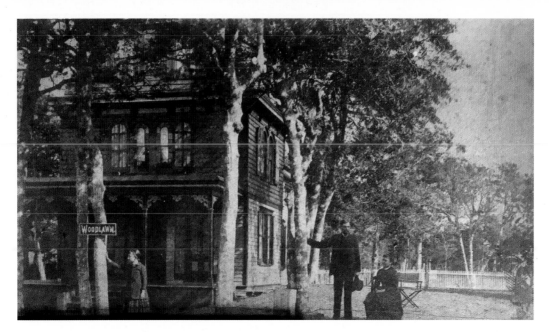

WOODLAWN, WEST LEAMING AVENUE, WILDWOOD: "Woodlawn, Dear Woodlawn," Mrs. Stephen Titus wrote of her family's Holly Beach home. This Victorian Second Empire was built in 1890 for the Titus family of Pennsylvania. Widow Josephine Titus, born 1836, was matriarch until her death in the 1910s. Mary Titus, born 1872, became head of household and lived here with her brother, William Titus, a clerk at a theater and later a painter. The quaint mansard cottage was expanded into a grand estate by realtor Peter Compare. Compare's addition includes a pointed tower, neoclassical bracketing and bay windows. In 2002, it became the homestead of attorneys David and Michelle DeWeese. *(WHS)*

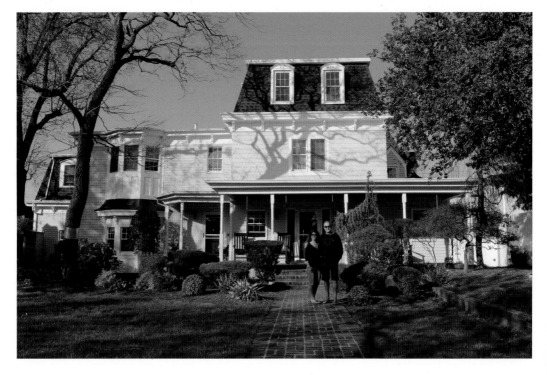

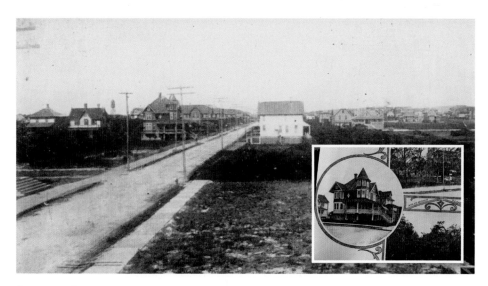

SCHMIDT HOUSE, PACIFIC AVENUE, WILDWOOD: A leather worker and the first vice president of Marine National Bank, George Nelson Smith was the first resident of this 1900 Queen Anne Victorian. A decade after joining the bank, he was spared from the *Titanic*'s maiden voyage by arriving an hour late to the harbor. Later the house was home to Alma Bell, proprietor of Bell's Variety Store, then Dr. Clyde Smith, who held his practice inside from 1929-1936. It became a rooming house, with the world's tallest woman, Sandy Allen, a tenant during her 1978 boardwalk performance. The longest residents were the Bonelli family, owners of Bonelli's Market, from 1940-2016. In 2016, Scott and Diane Schmidt moved in and began restoring their dream home, a "big old house at the shore." *(WHS)*

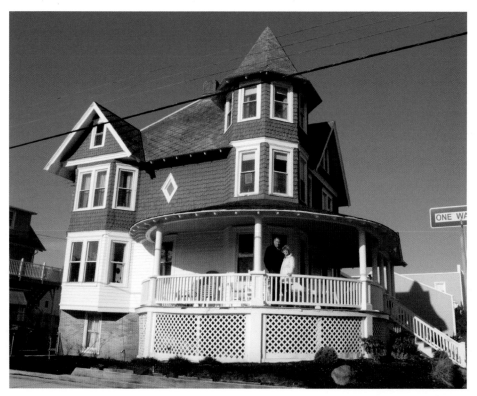

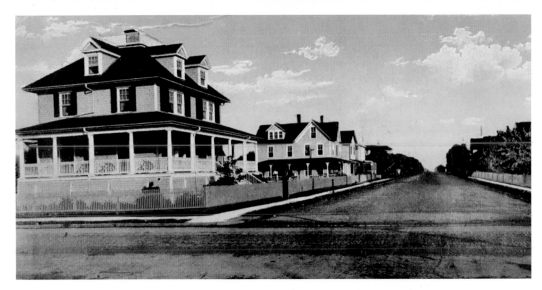

REESE RESIDENCE, TAYLOR AND PACIFIC AVENUES, WILDWOOD: A forgotten Holly Beach founder built this Classical Revival in the 1890s. John Reese, b. 1860, was a retired Philadelphia iron manufacturer when he came to Holly Beach in the 1890s. He helped establish the island's gas and water services, provided the land to build Wildwood High School, was on city council and served as a director of Marine National Bank. He worked as a ship chandler (ship supplies vendor), a highly profitable and influential career in the socioeconomics of the booming fishing industry. When Holly Beach merged with Wildwood, Reese became a member of the Sinking Fund Commission. The house was built near the curb, but was moved to the center of the property between 1949 and 1956. Between those years, it was bought by Esso Service Station owner Joe Spuhler for his family. *(WHS)*

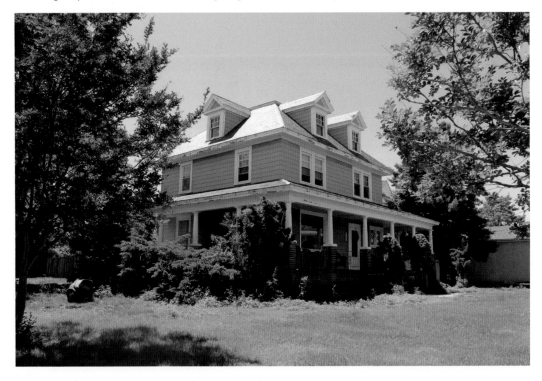

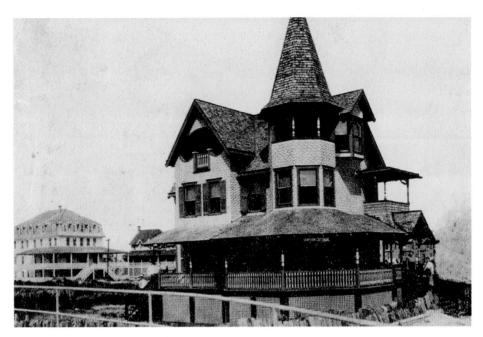

GRAYSON COTTAGE, EAST LINCOLN AVENUE, WILDWOOD: This turn-of-the-century "cottage" was one of the most significant instances of Gothic Revival and Queen Anne Victorian in Holly Beach, with a witch hat almost 20 feet tall. When the Grayson was built, it bordered the boardwalk (before the boardwalk was moved farther east) and was 100 feet from the ocean. In the *King's Guide to Wildwood*, it boasted thirty rooms which were rented by various proprietors over the years, including Katie C. Miller, Ida M. Hartman, E. J. Addis, James H. and Jennie Haslett, and Adam and Anna Kempa. The Grayson was remodeled and added onto, its porches enclosed, gingerbread unreplaced and witch hat removed. It went neglected for years, but could one day be restored to its original splendor. *(WHS)*

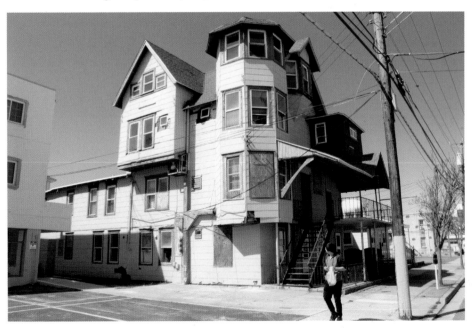

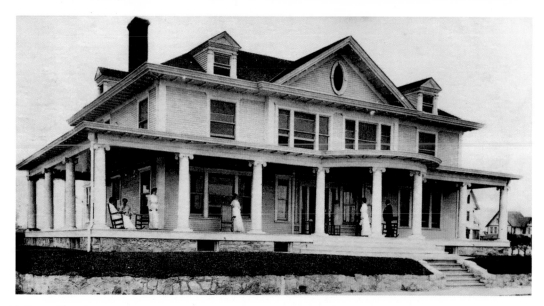

J. THOMPSON BAKER HOUSE, ATLANTIC AVENUE, WILDWOOD: Philadelphia lawyer Jacob Thompson Baker and his brothers left Pennsylvania in the late 1800s to develop the wooded Five Mile Island. In 1904, he built his summer home, an oceanfront, neoclassical mansion inspired by the White House. Baker became the first mayor of Wildwood in 1912, serving the shortest term because he was elected to Congress eleven months later. Woodrow Wilson stayed at Baker's house several times before becoming president. Baker's wife Margaret and their daughters were active suffragettes, forming the Wildwood Civic Club in 1912. In 1919, their daughter Katherine died of tuberculosis after serving in the Red Cross, and Baker died ten months later. The Civic Club bought the house in 1934 for $6,000 and used it as its clubhouse for more than eighty years. It is the only residential home in Wildwood on the historic register. The Civic Club sold the house to a private owner in 2018. *(WHS)*

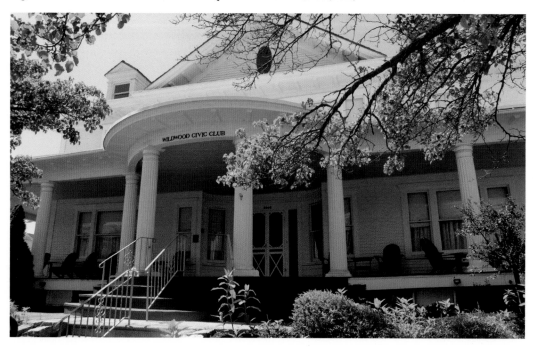

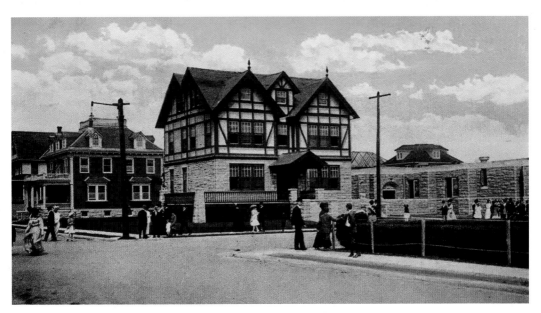

ST. ANN'S PARSONAGE, PACIFIC AVENUE, WILDWOOD: Wildwood's first Catholic mass was held in a bungalow on Andrews Avenue in 1895. In the next twelve years, the island's Catholic population outgrew the bungalow, built a church and parsonage at Roberts and Pacific, then outgrew that. Daniel Wade and Charles Gallagher donated a lot between Glenwood and Magnolia, stipulating that a church be built there. Christopher J. Scully, first trustee of St. Ann's Church, built the new church and parsonage in 1909. Reverend James A. Maroney was the first resident of this Tudor, a rare example of Victorian Stick-Style, which uses half-timbering to express the building's structural framing. In 2008, St. Ann's merged with Assumption Church in Wildwood Crest to form Notre Dame de la Mer, and the parsonage became a convent. (WHS)

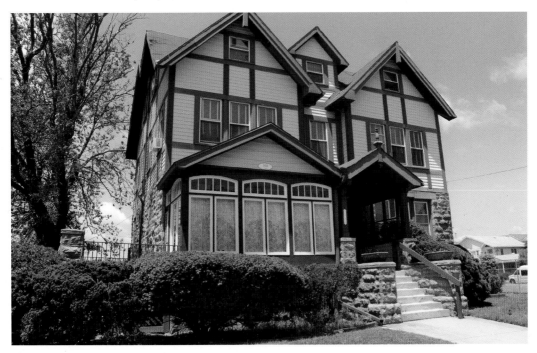

THE PINES, PINE AND PACIFIC AVENUE, WILDWOOD: New York contractor B. VanHorn, born in 1861, came to Wildwood in 1896, building a grand Victorian home in 1897. VanHorn invested in the borough's railroad, became tax collector and raised five daughters with wife Ella. After his death, Ella opened the home as a boarding house called The Pines, and Doris got a cashier job at a tea shop up the block. The Pines was managed by different proprietors until the 1960s, and downstairs, different businesses set up shop. E. Weisler sold bathing suits in the 1920s, W. Mathis sold confections in the 1930s, and George Kooker ran a luncheonette in the 1940s. Cullen's Restaurant, Ford's Snack Shop and Magdola's Cut Rate came next, then in 1966 Leon Fulginiti opened an Italian-American eatery. Fulginiti lived in Wildwood until his death in 2004. *(WHS)*

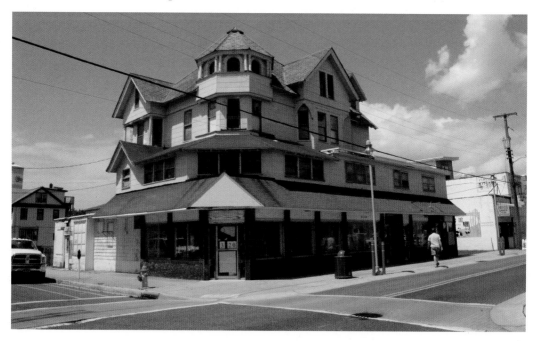

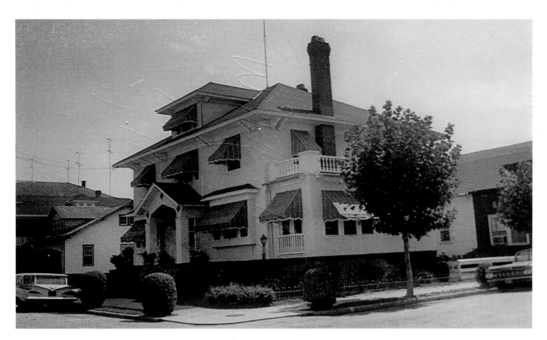

ROBERT KAY RESIDENCE, EAST GLENWOOD AVENUE, WILDWOOD: Robert J. Kay, secretary and treasurer of Beecher-Kay Realty, was born in Philadelphia in 1882. Beecher-Kay is the oldest family business in the Wildwoods, formed in 1907. Outside of realty, Kay served as Wildwood tax collector and city treasurer starting in 1912, and resided at 122 East Glenwood Avenue. About 1921, the year Kay was elected as a state assemblyman, he and wife Clara (*nee* Eynon) built this decorated 1911 Craftsman on the same street, but much closer to the ocean. Kay lived here while serving on boards at Marine National Bank, Five Mile Beach Building and Loan Association, the Sinking Fund, and Wildwood Bungalow Company until his death in 1955. (*WHS 1960*)

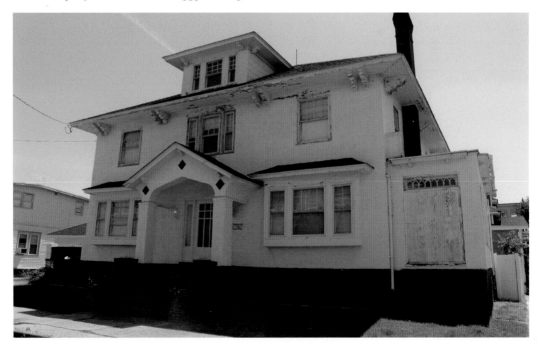

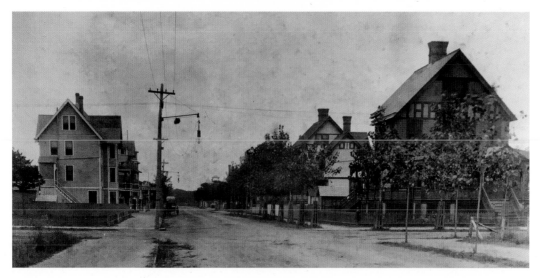

ALBERT AUSTIN HOUSE, MAGNOLIA AND PACIFIC, WILDWOOD: Built *circa* 1900, this Victorian house's original shingles are still visible, but the H-shaped half-timbering was covered with aluminum siding. It was the residence of Albert D. Austin, a freemason and dealer in coal, cement and building materials. He was the secretary of W. H. Austin Company, located at Spicer and the railroad. In the days of candlestick telephones, the company's phone number was 5. The company president was Albert's father, Elwood R. Austin, and its vice president was Albert's brother William H. The Austin family came from Haddonfield in the 1900s-10s. Albert died in 1931 at age forty-nine and is buried in Cold Spring Presbyterian Cemetery with his wife Martha, who died in 1970. *(WHS)*

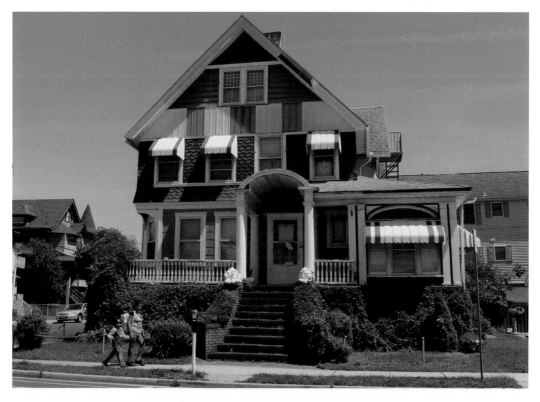

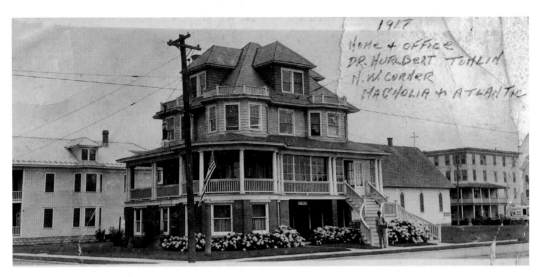

DR. TOMLIN SANATORIUM, MAGNOLIA AND ATLANTIC, WILDWOOD: Dr. Henry Hurlburt Tomlin, born in 1877, graduated from Pennsylvania Medical School and came to Wildwood. In 1905, he built his Victorian home and married Bessie Noyes Baker, daughter of Philip Baker, in 1909 at the house. Tomlin opened the Wildwood Sanatorium in his home in 1911 for the treatment of convalescents and nervous conditions. He promoted the health benefits of the salt air and seashore climate, and used state-of-the-art electrotherapeutic and hydrotherapeutic equipment. In 1918, Tomlin began serving in the Army's medical corps, but continued to operate the sanatorium after his return. Tomlin died suddenly in 1939 during a South American cruise with Bessie, who would die decades later in 1972 in the house. In 2006, Carol and Rich Junz bought the home, restored it and established Enchantra's Bed and Breakfast. The spirit of Bessie is among many reputed to haunt the house. *(WHS)*

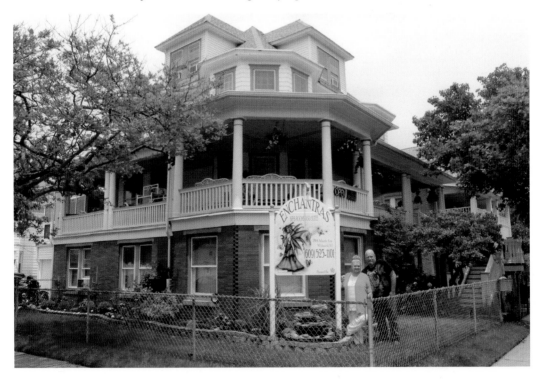

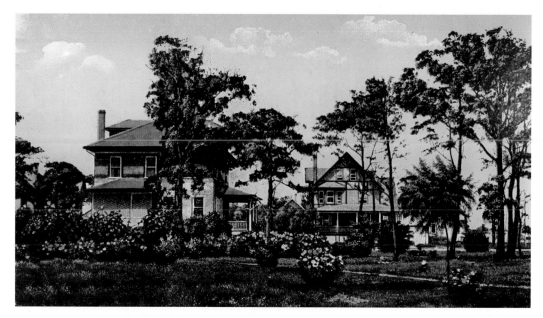

DR. DANDOIS RESIDENCE, WEST MAGNOLIA AVENUE, WILDWOOD: Born in Pennsylvania in 1866, Dr. George Dandois came to Wildwood in the 1910s to work as a general practice physician. With his wife Jennie and four children, Dandois moved into a *circa*-1892 Tudor house that also served as his office, a common practice for doctors of the era. Dandois served as chair of the cancer control subcommittee on the Cape May County Medical Society. In 1967, this handsome Tudor across from Magnolia Park became the home of Larry and Rosemarie Snyder and their children Deborah, John and Kimberley. Larry was a councilman, zoning board member and breadman, and Rosemarie, who still lives here, was a doll artist and owner of Snyder's House of Dolls. *(WHS)*

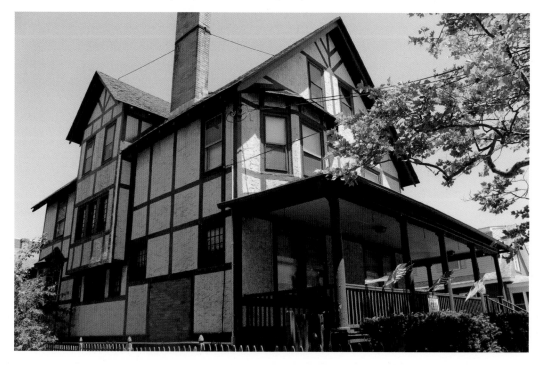

Jason Buck Residence, Central Avenue, North Wildwood: Anglesea Mayor Augustus Hilton built this Queen Anne at the turn of the twentieth century, where he lived until 1905, when he moved and sold it to Jason Buck. Buck, a first cousin of Samuel and George Buck, came to the island with wife Edith by 1885 and worked at the US Life-Saving Service. He built a grocery store and house on Walnut Avenue, helped found the Anglesea Methodist Church, and worked in the fishing industry. Erosion forced the Bucks further inland, which is why they bought this house. While Buck lived here, he served as postmaster and on city council, being the only dissenting vote on the 1906 proposal to change Anglesea's name to North Wildwood. He died in 1931. *(WHS)*

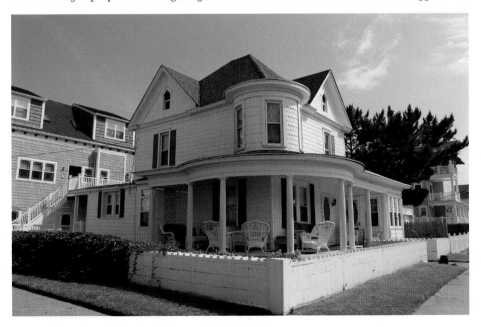

HARRIS HOUSE, FOURTH AVENUE, NORTH WILDWOOD: A stepson of the first Holly Beach mayor Franklin VanValin, J. Albert Harris (pictured above) came to Holly Beach as a child in 1882. Harris was instrumental in organizing the Chamber of Commerce in 1898 after holding a meeting in his hotel, the Edgeton Inn. By 1910, Harris was appointed the fourth (and later the sixth) postmaster of Wildwood, and resided in this Victorian house with his wife May and son James. He served as postmaster until 1914, then again from 1923-1934. Throughout his life, Harris was a Board of Education member, a firefighter, a chief petty officer in the Coast Guard Auxiliary during World War II and the president of Casino Pier. He died in 1950 after suffering a heart attack at home. *(WHS)*

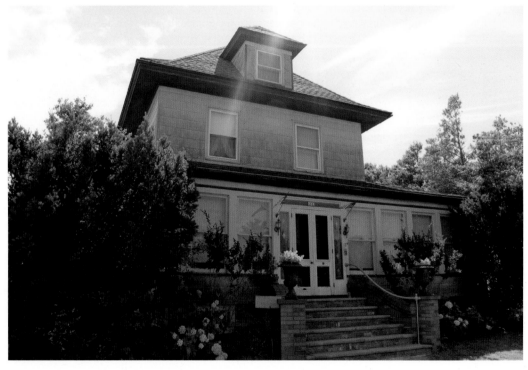

CORWIN HOUSE, EAST 17TH AVENUE,
NORTH WILDWOOD: This 1900 Queen
Anne Victorian is one of several with
the same blueprint throughout the
Wildwoods; others are at Heather and
Pacific, Magnolia near Pacific, 20th near
Surf and 25th near Atlantic. These were
built by Frederick Sutton, developer
and Marine National Bank director
who died on the *Titanic*. The house
on 17th was first the summer home
of Elizabeth, NJ, accountant John A.
Corwin. It was purchased for $2,600 in
1938 by Michael and Elizabeth Ciampi of
Philadelphia, and Michael converted it
into a rooming house. In the 1940s, the
turret caught fire but was extinguished
before fire spread. The house was
passed down from their children to their
grandchildren, Denise and David Pizza.
They replaced the turret in 2008.

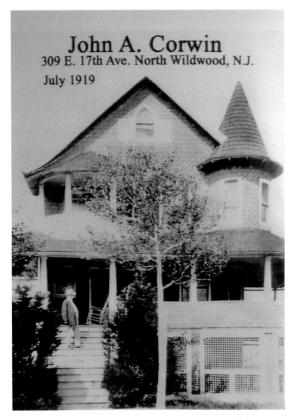

John A. Corwin
309 E. 17th Ave. North Wildwood, N.J.
July 1919

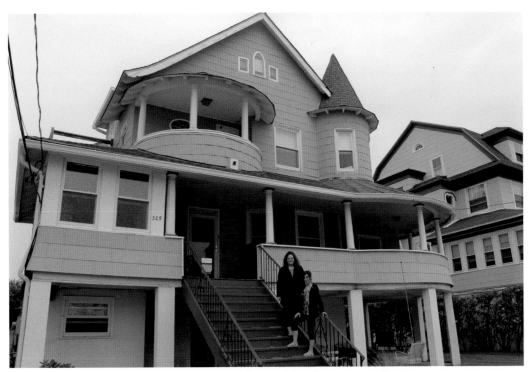

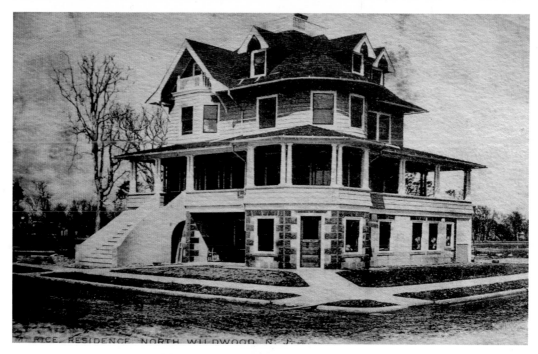

CANDLELIGHT INN, CENTRAL AVENUE, NORTH WILDWOOD: This Queen Anne Victorian was a kit home designed by J. H. Daverman & Son and built in 1906 by Cape May County Engineer Leaming Rice. Leaming built his home a block away from the beach, but a growing shoreline slowly carried the waterfront three blocks away. In 1947, Leaming died and his wife Sarah followed a year later. Their son William became county engineer and head of house until he died in 1980, followed by his wife Reba in 1984. Around 1985, Diane Buscham and Paul DiFillipo established the Candlelight Inn Bed & Breakfast, the first B&B in the Wildwoods. The gas chandeliers were converted to electric, and the cabinetry and balustrades were kept original. Wanda and Michael O'Brien became innkeepers in 2014.

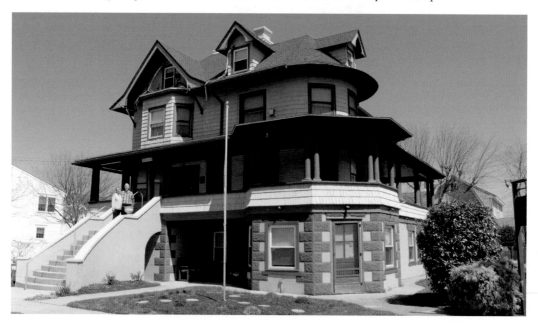

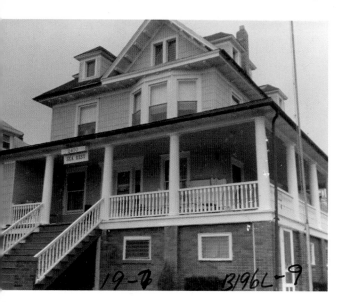

THE AVAIR, CENTRAL AVENUE, NORTH WILDWOOD: This *circa*-1912 Queen Anne with servants' quarters, a ladies' parlor and a rare Humphrey Radiant Fireplace was the longtime home of widow Frances Bowers. Over the years, it was divided into seven apartments and called the Sea Rest apartments by Kendul and Ruth Kennedy. Kendull was on the North Wildwood Fire Department. At a barbecue the Kennedy's hosted in the 1980s, fire chief Paul Amenhauser met Patricia, a tenant at the Sea Rest. They married in 1987, hosting their wedding in the house. In 2013, Terry Oestreich and Mary Szidloski purchased and restored the house. They named it the Avair for a Celtic mythological woman who was joyful, radiant and beautiful. *(WHS 1982)*

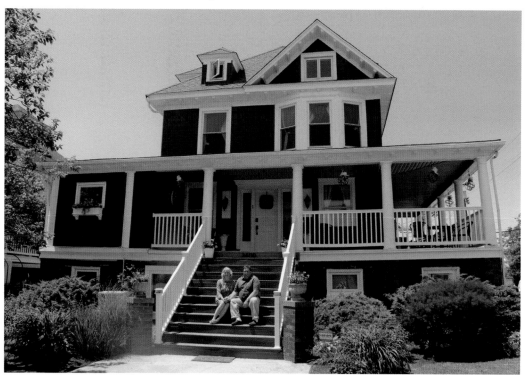

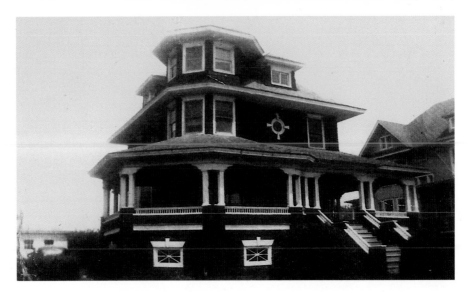

REA RITA, CENTRAL AVENUE, NORTH WILDWOOD: In 1902, Henry Dyer Moore and wife Mary of Haddonfield bought from North Wildwood Land Company a new Queen Anne Victorian, one of a handful built on the island with the same blueprint. Moore was a financier who funded construction of Haddonfield's grandstone First Presbyterian Church and the Henry D. Moore Library in his hometown of Steuben, ME. In 1914, the house became the home office of physician Dr. William A. Hamilton. John and Agnes Huver operated the Rea Rita furnished rooms from 1944-1960, named for their daughter Rita. When Rita was a child, she pronounced her name "Rea," so the Huvers added it to the name. Later, Michael and Marie McWilliams renamed it De Paul Rooms. Anthony and Alexis DeRemigi moved in in 2017. Alexis was general contractor during restorations, which were featured in a 2018 episode of HGTV's *Beachfront Bargain Hunt: Renovation. (WHS)*

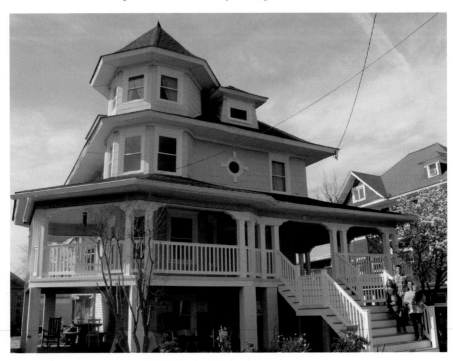

ADAMS-MCGINNIS-GALLAGHER RESIDENCE, CENTRAL AVENUE, NORTH WILDWOOD: This 1905 Queen Anne went from clergyman's home to cardplayer's den. It was the summer home of the family of Baptist Rev. Isaac Bagley, the pastor who saved the Camden Tabernacle Baptist Church from closing due to low membership in 1882. Bagley also worked as a film censor in the 1910s and 1920s. Bagley died in 1943. When Central Avenue became a drag strip, the bottom floor of this house held a gambling lounge. Later converted to a boarding house, the home was ultimately purchased in 2013 by Patrick and Kristie McGinnis, Michael and Brian Adams, Mickey Adams and Joe Gallagher. Patrick, a carpenter, restored it and salvaged everything original. *(WHS)*

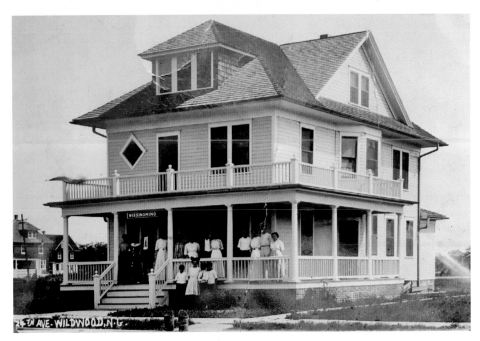

CAMEO ROSE, EAST 24TH AVENUE, NORTH WILDWOOD: John Schild bought a plot from North Wildwood Land Company and built a Colonial Revival house with Victorian features in 1907, one of only three houses on the block. The Schilds named their home the Wissinoming after the Philadelphia neighborhood. Later, the house was home to baker Bernard Gundlack and wife Fanny. It was converted into nine boarding-house rooms and two apartments, named Clearview Apartments for its view of the ocean. After being abandoned for years, it was purchased by Len and Pam Bross in 1995 and converted into the Cameo Rose Bed & Breakfast. Len, a carpenter, ripped out moldy carpet and stripped painted moldings, and the Brosses furnished it with antiques.

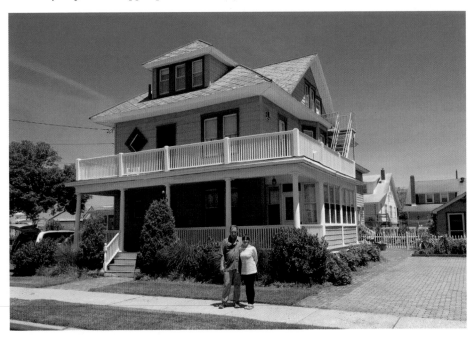

EDWARD M. SHIVERS' HOUSE, ATLANTIC AVENUE, NORTH WILDWOOD: A member of the fishing family descended from Thomas Cheevers of Ireland, Edward Marmaduke Shivers was born in 1833. As an adult, he was a plasterer who resided in Middle Township with his wife Cornelia and their children. Edward was elected mayor of Anglesea from 1890-93 during which he built this Victorian Second Empire. After his mayoral term he worked as tax collector of Anglesea. He died in 1911 and is buried in the First Baptist Cemetery in Cape May Court House. In the 1920s, the Gillooley family turned the house into the Mantua Apartments. It was run as apartments until Thomas and Eileen Smith changed it to condo units. Eileen's sister Kathy McCarthy and her husband Daniel have resided here since 2009. *(WHS 1982)*

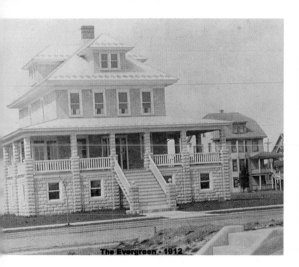

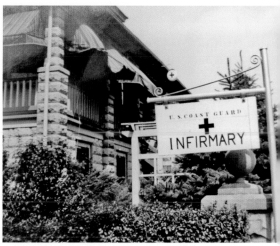

SUMMER NITES, ATLANTIC AVENUE, NORTH WILDWOOD: Built in 1912-13, this American Foursquare was a Coast Guard infirmary during World War II. Cape May and the Wildwoods were both integral to American defense during this war, and North Wildwood even had its own concrete lookout tower. Previously the house had been the residence of Augustus Ward Borgmann until his 1932 death. After the war, the house was converted to apartments and was known as The Evergreen for decades. In 1995, Rick and Sheila Brown purchased it. They refurbished it and opened the Summer Nites Bed and Breakfast in 2003, with a different 1950s theme in every room. Rick, a builder by trade, turned a bedroom into a midcentury diner, and installed an authentic vintage refrigerator, kitchen, and Coca-Cola machine.

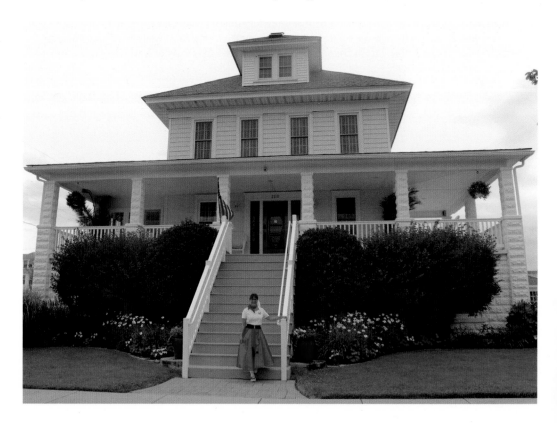

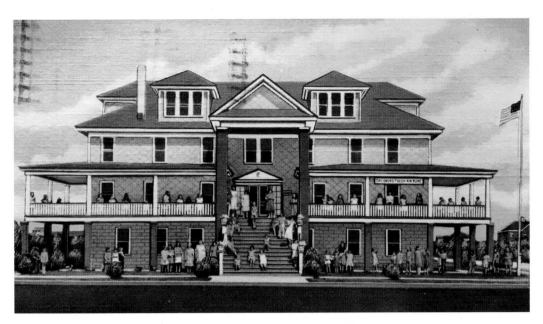

CHILDREN'S FRESH AIR HOME, 11TH AND SURF, NORTH WILDWOOD: In 1896, L. Ida Dukes, a forty-one-year-old mother of six, hosted a trip to the Delaware Bay for city children whose parents could not afford vacations. Such trips became regular occurrences, and in 1911 she brought a group of children to Wildwood for the first time. In 1923, the Children's Fresh Air Home, a Classical Revival with wraparound porch, was built as a place for city children to enjoy summer stays at the shore. After Ida's death in 1937, different superintendents kept the home in operation, but in 2006, structural concerns forced the house to close. Since then, fundraising has benefitted restoration, which began with the completion of a new foundation. The annual Ride to Rebuild was a major fundraiser for the restoration. *(WHS/Bottom photo provided by Children's Fresh Air Home)*

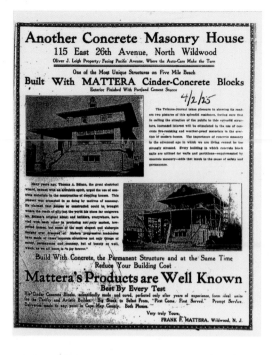

Another Concrete Masonry House
115 East 26th Avenue, North Wildwood
Oliver J. Leigh Property; Facing Pacific Avenue, Where the Auto-Cars Make the Turn

One of the Most Unique Structures on Five Mile Beach

Built With MATTERA Cinder-Concrete Blocks
Exterior Finished With Portland Cement Stucco

4/2/25

Build With Concrete, the Permanent Structure and at the Same Time
Reduce Your Building Cost

Mattera's Products are Well Known
Best By Every Test

Very truly Yours,
FRANK F. MATTERA, Wildwood, N. J.

MATTERA CONCRETE HOUSE, EAST 26TH AVENUE, NORTH WILDWOOD: In the 1920s, builders experimented with different construction materials. Frank Mattera, a mason, general contractor and landscaper, built a house with his own concrete blocks produced in North Wildwood. He advertised the house in local newspapers to show the strength of his concrete blocks, which he called the fireproof, weatherproof way of the future. George W. C. and Minnie Wilson were the first residents of the concrete house and lived here for decades. St. Simeon's By-The-Sea Church, which is next door, bought it in the 1980s as a rectory. Proving its permanence, the concrete house still stands in 2018. *(WHS)*

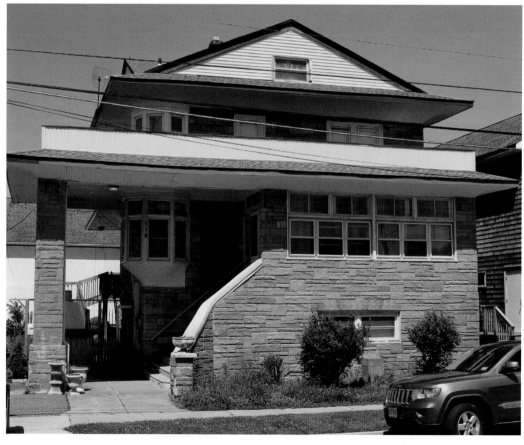

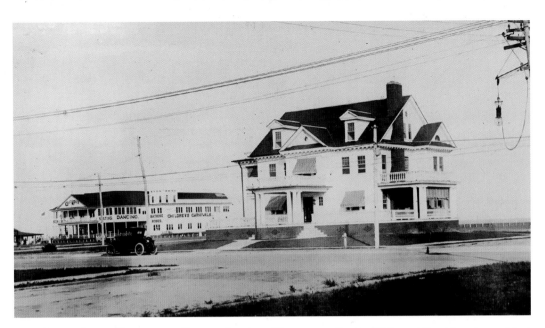

PHILIP BAKER RESIDENCE, PACIFIC AVENUE, WILDWOOD CREST: Wildwood Crest founder and first mayor Philip Pontilius Baker built his stately, White House-inspired mansion in 1913. The residence, which includes six bedrooms, four bathrooms and even a music room, was completed three years after the Crest incorporated. It was alleged that Woodrow Wilson gave a presidential acceptance speech from one of the porches. Bakey enjoyed the house for less than a decade, for he died in 1920, and is buried in a Baptist cemetery in Cape May Court House. Before coming to Five Mile Beach, Baker, a democrat, was elected to the state Assembly and later the state Senate. *(WHS)*

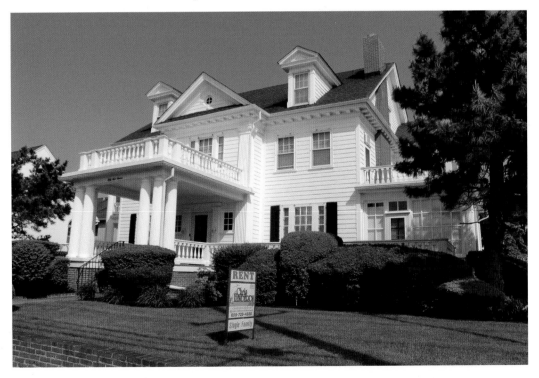

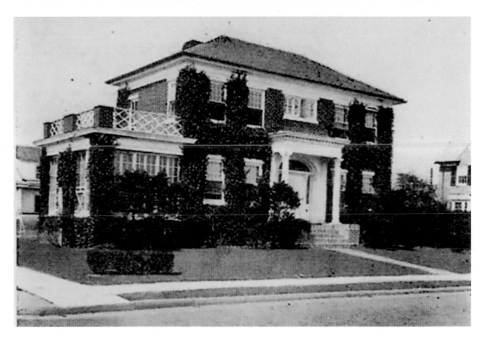

CRANE RESIDENCE, PACIFIC AVENUE, WILDWOOD CREST: Heber Crane was born in Maryland in 1872 and moved to Manhattan at the turn of the twentieth century to work as a treasurer for a mining company. He married Margaret Stuart, daughter of Wildwood founder J. Thompson Baker, and they had a son, Thompson, in 1905. In 1912, the Cranes moved to Wildwood Crest, where Heber accepted a position as treasurer of Wildwood Trust and Title Company. They built a classical revival home in the late 1910s, around the time Heber was promoted to president of the company. He also became chairman of the board of directors for Union Bank. Margaret died of an embolism in 1921, two years after the death of her sister Katherine, a decorated World War I nurse who fell to tuberculosis. Francis Baker, Margaret's sister, lived here after Heber's 1926 death.

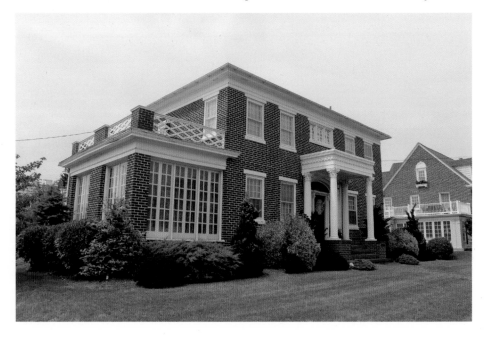

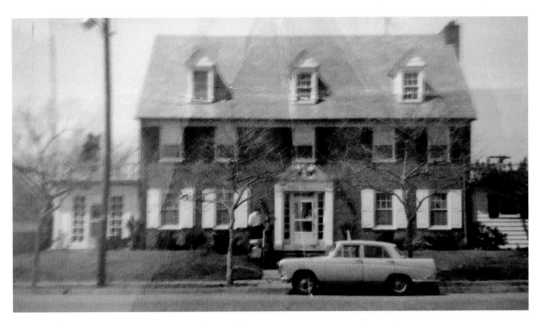

PALMER WAY HOUSE, PACIFIC AVENUE, WILDWOOD CREST: George Steinmetz Dunlap of Philadelphia was proprietor of Dunlap Printing Company, founded by his uncle Henry C. Dunlap. The company printed municipal literature such as ballots for city elections. He built this brick Colonial Revival as his family's summer home, allegedly being inspired by an identical house near Philadelphia. He furnished the home entirely with J. B. Van Sciver furnishings. After Dunlap's 1937 death, the home was purchased by Palmer Way in 1944. Palmer served as a county judge, and his son Palmer Jr. was mayor of Wildwood Crest from 1949-1957. Palmer Jr.'s son John Way and his wife Betsy inherited the house from Palmer Jr., who inherited it from Palmer. In 2011, the Ways' extensive renovations earned them the Heritage Award for preservation in Cape May County.

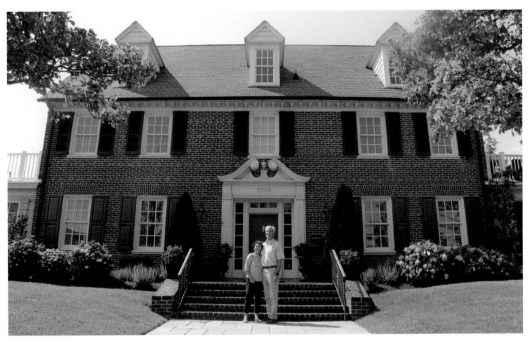

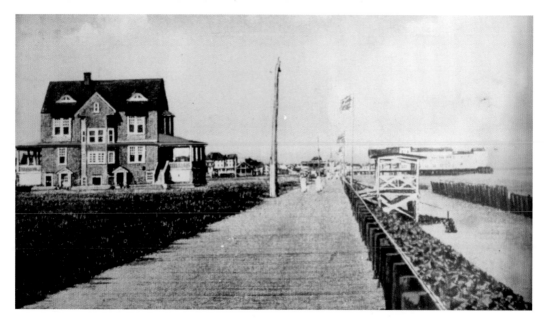

GILL MANOR, EAST COLUMBINE ROAD, WILDWOOD CREST: Built between 1909-1912, this late Victorian manor boasts neoclassical elements and an ocean view from its second-story windows. It was built for James P. Gill, president of the Philadelphia-based James P. Gill and Company, which "was organized for the purpose of manufacturing high-class glass articles of all kinds, specialising in the manufacture of glass for gas and electric purposes," according to the *Reading Times* in 1919. It was never divided into apartments, and always was a year-round single-family residence. Since 1995, it has been the Tirello residence. Sensing a spiritual presence in the house, Melanie Tirello had it blessed by a priest.

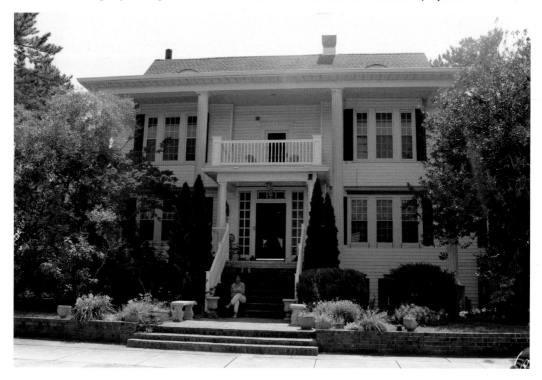

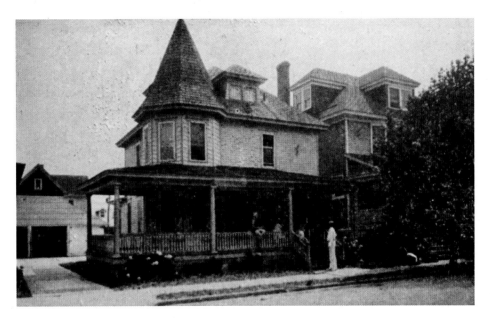

TOLAND HOUSE, EAST HEATHER ROAD, WILDWOOD CREST: One of many notable 1900s Queen Anne Victorian houses lining Heather Road, this house and the two houses on either side are believed to have been built for three affluent sisters. This style of summer cottage was popular for upper-middle-class vacationers, and variations on the style were built throughout the Crest. The Toland family purchased the house in 1987, converting it back into a single-family home from a duplex. Terri Toland has since called this house home. *(WHS)*

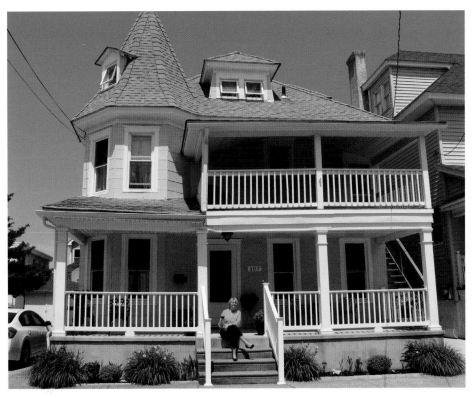

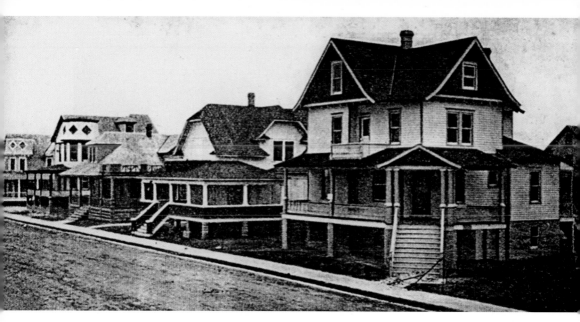

MALEC RESIDENCE, EAST HEATHER ROAD, WILDWOOD CREST: Heather Road is lined with incredible picturesque Victorian houses. One of the island's most photographed residential streets at the turn of the twentieth century, it appeared on several postcards at the time. It features the oldest houses in the Crest, so it's likely the Baker Brothers designed this street as public relations to attract families to build more homes. Built *circa* 1906, this Queen Anne was a summer cottage, so it has only one fireplace. In 1963, it was purchased by Casimer and Helen Malec as their summer house. After they passed away, their son Gary bought the house in 1983. Gary and Marian Malec raised two sons here and continue to reside here. *(WHS)*

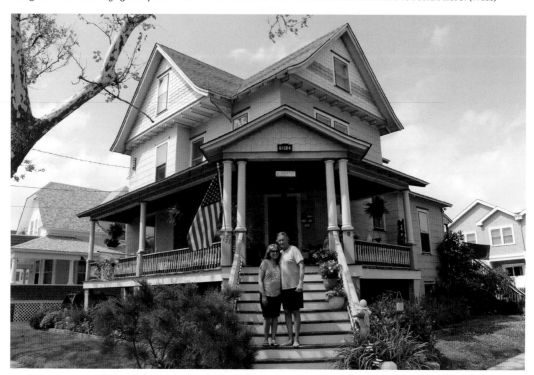

Heather Road, Wildwood Crest, N. J.

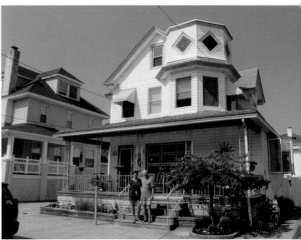

VICTORIAN SISTERS, EAST HEATHER ROAD, WILDWOOD CREST: These 1900s Queen Annes with Mansard towers stand side by side, as shown in the top photo on the previous page. The house above was the residence of Wildwood Crest Disposal Plant foreman Jacob Broomhall and wife Rosemary. Since 2011, it has been the home of Lois Lombardo and Al Rolek. The larger house below features servants' quarters and was supposed to be a home for "feeble-minded children," according to the first deed. It has history as a boarding house managed by Antoinetta B. Fox, and later named Natalka Villas by Theodore Duda, for his daughter. Since 1972, it has been Mike and Mary Baklycki's summer residence. *(WHS)*

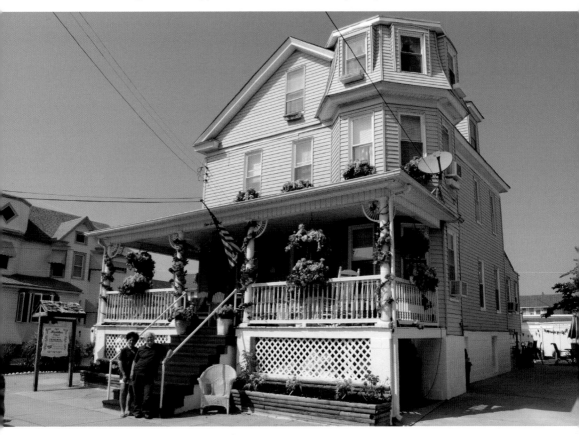

THE SUMMER WIND, EAST CROCUS ROAD, WILDWOOD CREST: A Philadelphia saloon proprietor, August Kop built this four-story Victorian mansion *circa* 1909. With stained-glass windows, separate sitting rooms for men and women, gas lighting and a bottom floor entirely for servants' quarters, Kop's mansion was one of the island's most extravagant. He enjoyed it for only a couple years, for he died in 1911. His widow Anna remarried Ambrose Dailey in 1916 and they lived here another three years. For a few decades it became the home of jeweler Richard Engelmann. In the late 1960s, Wildwood Crest became a vacation destination for American and Canadian Ukrainians, and this house was a Ukrainian restaurant and boarding house called Slavuta. In 2007, Dan and Nancy Pryor fell in love with the house and began converting it back into the grand home it once was. They nicknamed it "The Summer Wind" for Nancy's favorite song.

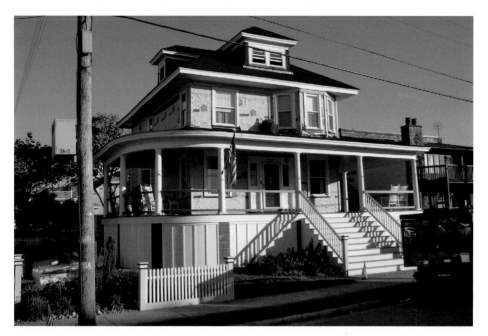

KING RESIDENCE, PARK BOULEVARD, WILDWOOD CREST: Charles W. G. King was born in England in 1862 and came to the United States in 1887. His wife Caroline came from Germany in 1878. Charles was a draftsman in Philadelphia, and wanted a home at the shore. The Kings built a Foursquare house with Victorian bay windows, porch and curved dormers in 1908; they lived here for the rest of their lives. Charles died in 1935. In 2000, Jerry Freal and Norm Bernard, owners of Calloway Realty, purchased the home and did a complete restoration. It has been their home since. *(Both photos provided by Freal and Bernard)*

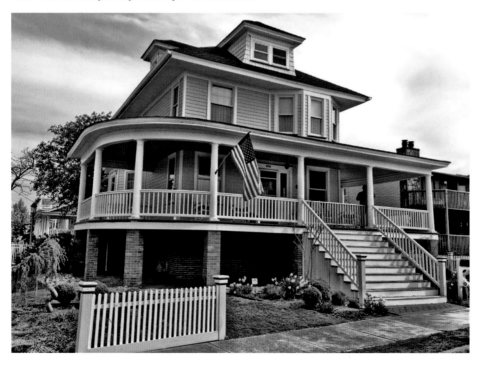

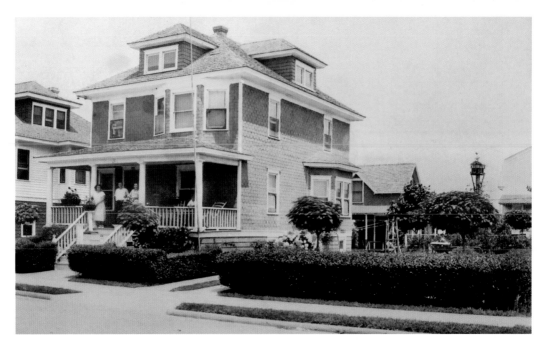

LETTS RESIDENCE, WEST WISTERIA ROAD, WILDWOOD CREST: The Wildwood Crest Corporation sold this lot to railroad car inspector Albert F. Letts in 1910, who built a cottage within a year. Albert and Hannah Letts eventually built a foursquare house in front and raised six children here. In 1919, they sold to Matteo and Assunta Galdi, who had three children together. Matteo died in 1920, and a year later Assunta remarried to Raffaele Scena, an Italian immigrant who had arrived in New York on a ship called the *Trojan Prince* in 1900. They resided in Philadelphia where Raffaele was a barber, and this was their summer home. In 1941, the house was sold to siblings John Reynolds and Sarah Hildebrandt and their spouses, and has stayed in the family since. It is now owned by Terri Campbell.

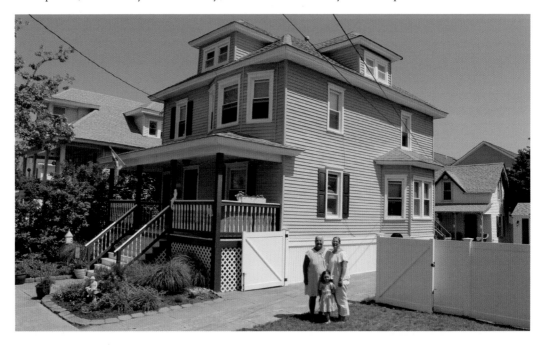

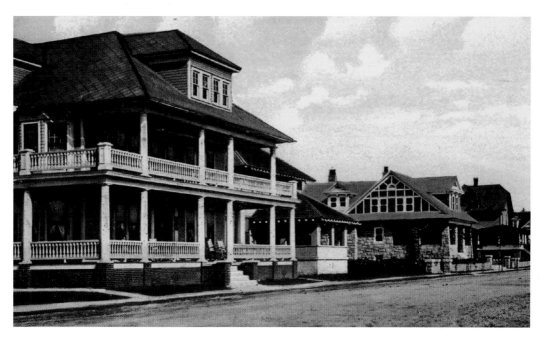

THE KRYM, EAST ASTER ROAD, WILDWOOD CREST: This Victorian-Craftsman apartment was built *circa* 1910 and was later called the Aster Apartments. In the 60s, the building was named The Krym and was rented to Ukrainians. At that time, Ukrainians made up a population of 5,000 visitors to Wildwood Crest. The area was even called the "Ukrainian Riviera." Sharon and Rick Baynton became proprietors, but when they were ready to retire from landlording, they still wanted to save the house. So, they converted it into six condos, built a pool and Victorian garden and continue to live here. *(WHS)*

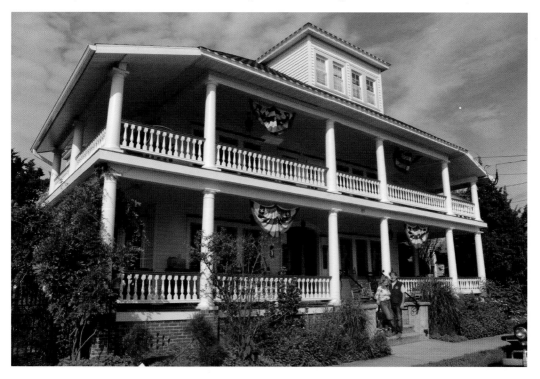

STUART RESIDENCE, EAST ASTER ROAD, WILDWOOD CREST: Thomas F. Lea, who was believed to be a ship captain, built this Victorian home in the mid-1900s, the first house on East Aster. Seen above at the far right, the house is believed to have a ship ballast built in its foundation. Starting during the 1920s housing boom, real estate broker Joseph Cianciarula lived here until his 1951 death. For the next four decades, the residence was a Ukrainian rooming house. In 2011, builder Brian Stuart bought the house and restored it. He and wife Laura had a foster home here in the 2000s. Stuart restored other homes in Cape May and Wildwood Crest, and said he's in the market "for other old houses to fix up, and not tear down." *(WHS)*

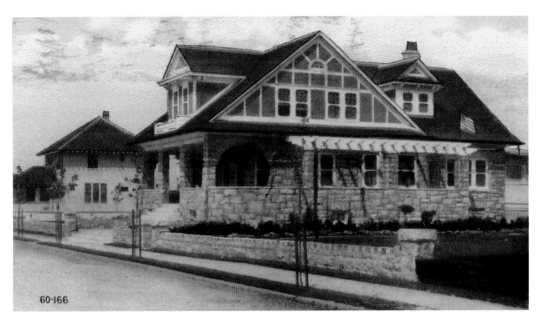

60-166

D. MILES RIGOR RESIDENCE, EAST ASTER ROAD, WILDWOOD CREST: D. Miles Rigor was a "secret service" man, meaning he was a private detective. His investigative agency in Camden was called Bottom Lines, and he solved cases from busting Pennsylvania Railroad ticket scalpers, to matching handwriting on forged checks to postcards. He came to the Crest with wife Evelyn in the 1910s and built this Craftsman bungalow with stones from a quarry that were delivered by train. After serving in World War I, Miles owned the Hotel Brighton in Wildwood, ran a real estate company with his son, and worked as a banker. The Rigors' family crest adorned the wall above the fireplace, but for an unknown reason, the design was never completed. During World War II, the Coast Guard allegedly set up officers' quarters here. *(WHS)*

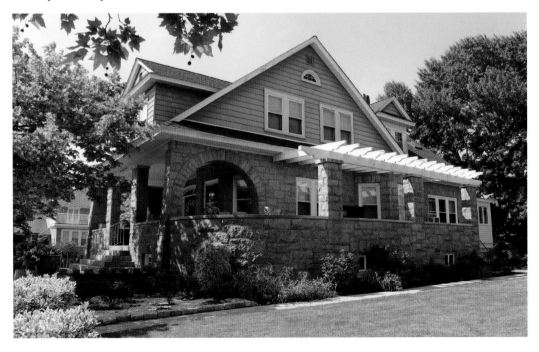

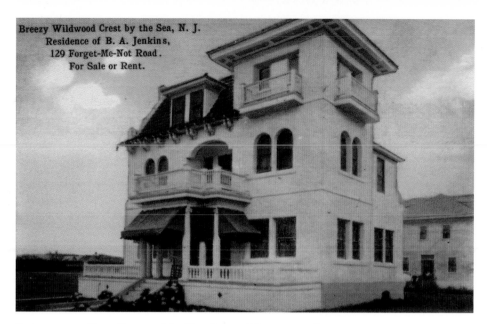

Breezy Wildwood Crest by the Sea, N. J.
Residence of B. A. Jenkins,
129 Forget-Me-Not Road.
For Sale or Rent.

PROVIDENCE, EAST FORGET-ME-NOT ROAD, WILDWOOD CREST: The Spanish house trend reached Wildwood Crest in the 1900s. American architects were designing homes with barrel-tiled roofs and stucco walls during the Arts & Crafts era, especially in temperate seashore towns. This home, built in the 1900s, draws from the Mission Revival style, inspired by white, stucco Spanish churches erected in California. Home to B. A. Jenkins, it was nicknamed "Providence," which means "the protective care of God." Called "one of the most beautiful seashore homes in America" in an early real estate advertisement, Providence has stained glass, neoclassical moldings, a music conservatory and ocean observatory tower. In 1999, it was purchased by Maura and Eric Hendrixson and Eric's parents, Bruce and Helene Hendrixson. *(WHS)*

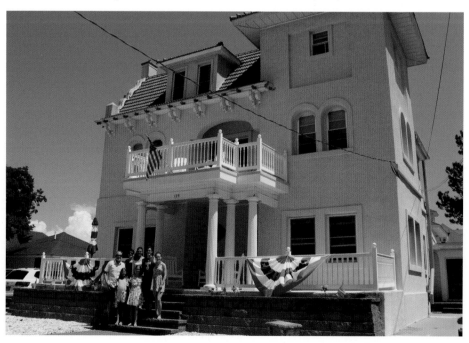

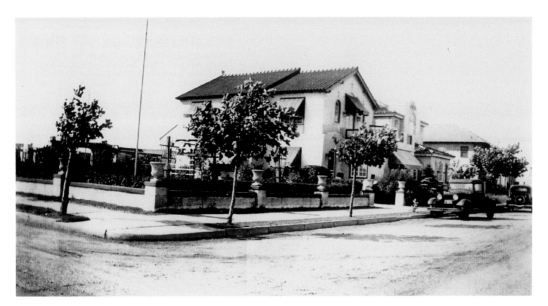

DAYTON RESIDENCE, STANTON ROAD AND PACIFIC AVENUE, WILDWOOD CREST: The area where this house now stands was once Turtle Gut Inlet, where the first privateer battle occurred during the Revolutionary War. In 1776, Captain John Barry, the "Father of the American Navy," led a defeat of British forces who had blockaded the Delaware Bay. The inlet where the only Revolutionary War battle in Cape May County took place was filled in to expand Wildwood Crest in 1922. This Spanish Colonial home was built in 1925, as the Arts & Crafts trend reached resort communities. Spanish houses were popping up in California, Florida and even Wildwood Crest in the 1900s-1920s. For years, this house was home to William Dayton, a real estate broker. *(WHS)*

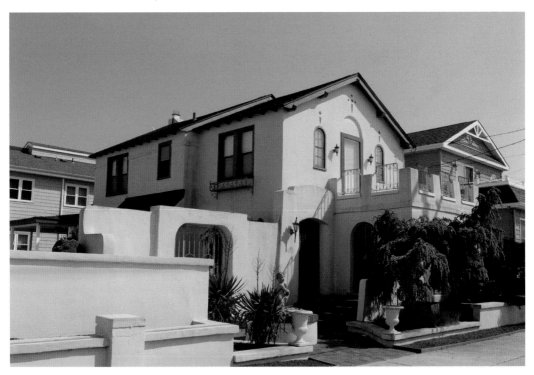

THE LOUISE, PACIFIC AVENUE, WILDWOOD CREST: This 1920 American Foursquare, pictured above from a distance in 1930, was originally the residence and business of widow Louise Stretch. Before this was built, she lived in the apartment building on page 99. Stretch made a living renting apartments in her new home, and opening Louise Art and Gift Shop. The shop had previously been on the boardwalk, but starting in 1921, it operated on the bottom floor of Louise's home. She sold centerpieces, scarves, pillows, aprons, card table covers, baby rompers, ribbon and Minerva wool, according to a city directory advertisement. Around 1956, William and Teresa Sanginiti of Italy purchased the home, and the house is still in the family. The cedar shingles are original. *(WHS)*

3

ADAPTIVE REUSE AND HOTELS

Some of the best turn-of-the-century buildings in the Wildwoods were Victorian hotels. As the railroad brought vacationers to Five Mile Beach, hundreds of castle-like hotels were built by developers between 1890-1910. With amenities such as wide breezy porches to stroll, unobstructed beachfront views, and even electricity and telephone, these fabulous hotels were state of the art. But most are gone.

The construction of the Garden State Parkway and the George Redding Bridge in the 1950s produced an abundance of automobiles, and with them, a demand for lodging that prioritized cars. Motels, short for "motor hotels," replaced most antique hotels.

The hotels that survived were converted into apartments, condos, storefronts, and restaurants. Several are in the retail district of Pacific Avenue. Converted hotels are interesting because of how much they have changed and the amount of different people they have held. Although they are more than just "houses," they fit in this book because they have been home to someone at some time. Often, permanent residents still live in the upper floors.

Adaptive reuse allows a historic place to take on new purpose that fits the current needs of the community. Historic buildings converted to condos have been the bright side of the mid-2000s development boom. Enough pre-1939 buildings were converted to condos in Wildwood to deem Wildwood one of the top ten New Jersey towns to *gain* pre-1939 housing units between 2000-2016. Percentage-wise, Wildwood ranked first in the state at 44.5 percent more historic housing units gained, according to the US Census Bureau.

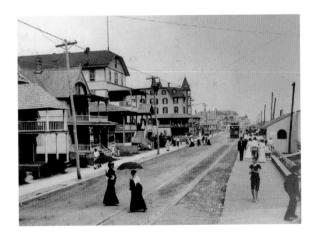

In the 1900s, Atlantic Avenue looked like Cape May does today. The buildings pictured are all gone now, but this chapter includes the hotels that survived: either by remaining hotels, or by serving another purpose. (*WHS*)

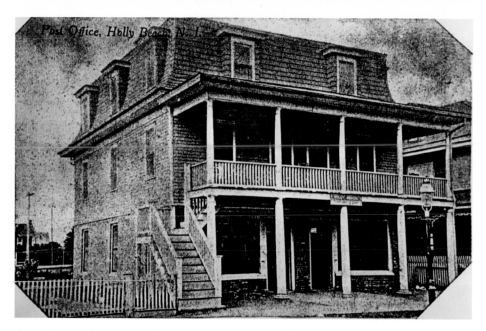

HOLLY BEACH POST OFFICE, EAST ANDREWS AVENUE, WILDWOOD: Holly Beach got a post office in 1883, two years before the town became a borough. This Victorian Second Empire with curved Mansard roof and decorative dormer windows saw thousands of packages and letters through its doors. The postmasters who served Holly Beach were Jennie Osborn, Frank Smith, William Forcum, Frederick Meyer and Israel Woolson. Holly Beach and Wildwood consolidated in 1912, and Holly Beach's post office was out of use a year later. Holly Beach Post Office was converted into apartments. *(WHS)*

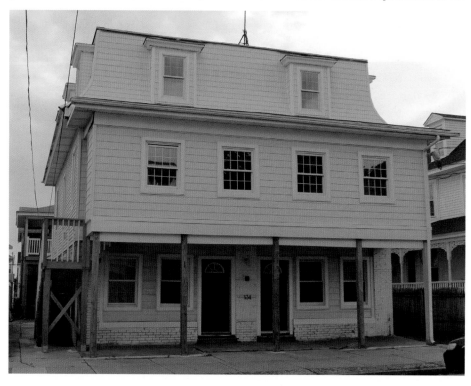

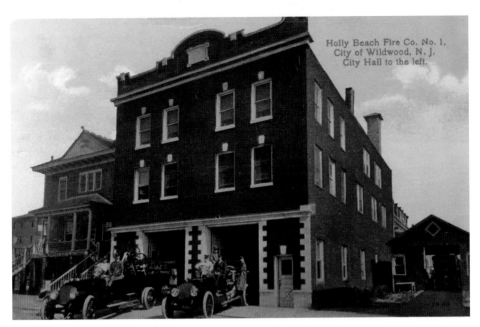

Holly Beach Fire Co. No. 1,
City of Wildwood, N. J.
City Hall to the left.

HOLLY BEACH FIREHOUSE, PACIFIC AVENUE, WILDWOOD: Holly Beach Fire Company formed after Wildwood and Holly Beach boroughs consolidated to form the City of Wildwood in 1912. The red brick firehouse was built in 1913 next to the first city hall and remained in operation until 1964, when operations moved to the current city hall. The old firehouse served as a furniture store before it was abandoned. In 2009, developer Mike Popper rescued the firehouse and converted it into condo units, restoring the original windows and brickwork. "This was a labor of love more than a profit-making venture," he told the Cape May County Herald. "We thought it was best for the community that it stays instead of tearing it down and just building regular condos." *(WHS)*

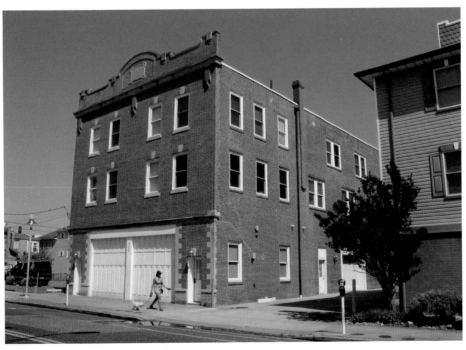

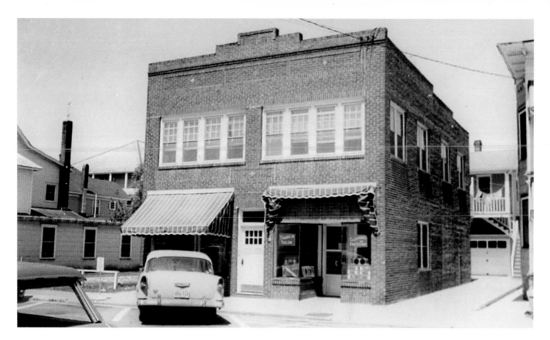

CHANGLIN TAILORING, EAST BURK AVENUE, WILDWOOD: Vincent Changlin was born in Italy in 1891 and came to Holly Beach to work as a tailor in the 1910s. He and Harry Cinalli, also from Italy, started a tailoring business called Changlin & Cinalli at 4612 Pacific Avenue. Vincent and wife Maria lived above the business until Changlin and Cinalli went in different directions. The Changlins moved to a 1920s brick mixed-use residence, which was built in resemblance to the Holly Beach Firehouse. They raised their three children here and Vincent operated his tailoring shop on the bottom floor until shortly before his 1966 death. Vincent and Maria are buried in Fairview Memorial Cemetery in Cape May Court House. *(WHS 1960)*

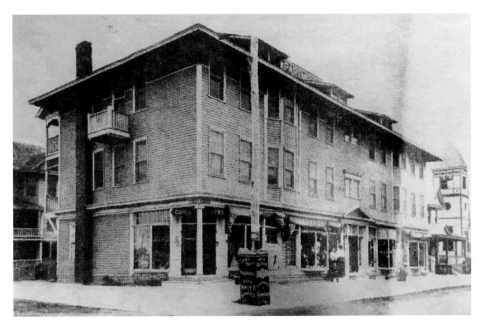

THE SOMERSET, PACIFIC AVENUE, WILDWOOD: Built *circa* 1901 by William Garrison, this building has been called "home" by countless residents and "place of business" by numerous names of Wildwood fame. Mrs. E. Parker Pharo ran Somerset Apartments upstairs until selling to Edgar A. Brown in 1908. Starting in 1922, peddler Benjamin Gidding and wife Fanny ran the apartments and rented to a candy store and bakery below. The Grassi family bought it in 1946, but the Realtor allegedly absconded with the deposit, forcing the Grassis to save up money to buy it again in 1948. Easy Markets Deli and Porecca and Santini Co.—later Grassi & Sons Furniture—were opened downstairs. In 2001, it was sold and renovated, with the upstairs converted to condominium units. *(WHS)*

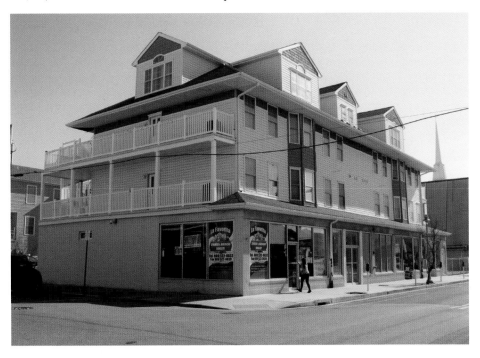

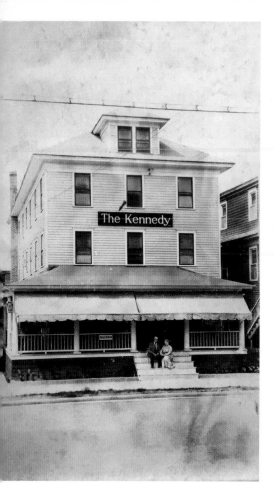
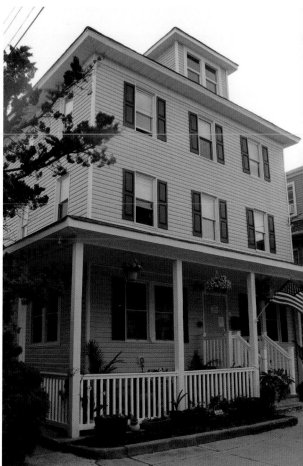

THE KENNEDY, EAST ANDREWS AVENUE, WILDWOOD: William Kennedy was fifty years old when he built Hotel Kennedy in 1910. Four stories tall, this foursquare-style hotel was constructed with about two dozen rooms. William retired in the mid-1920s and John W. Shipton became proprietor of the hotel. Ownership changed hands over the decades, but the Hotel Kennedy sign stayed fixated to the front wall for many years. The Kennedy is now a rooming house, but hasn't lost its classic look. *(WHS)*

WILDWOOD INN, EAST MONTGOMERY AVENUE, WILDWOOD: A late Mansard-style hotel, The Beachwood was built in 1904. Its proprietors over the years were Charles Kurtz, Jacob Mertz, N. Werrin, Bessie Goldman, Ted Dauginas and Dan Gareau. In the 1970s it was converted to a rooming house. In 2015, Mahesh Shah and Hiren Panwala renamed it the Wildwood Inn and changed it back to a hotel. The fourth floor, which was once the bathhouse, was converted to hotel rooms. One of the few original hotels left, Wildwood Inn still has its plaster walls, intricate wooden railings, banisters and doors, but its rooms have gained modern amenities. The building to the right in the postcard was the first city hall. *(WHS)*

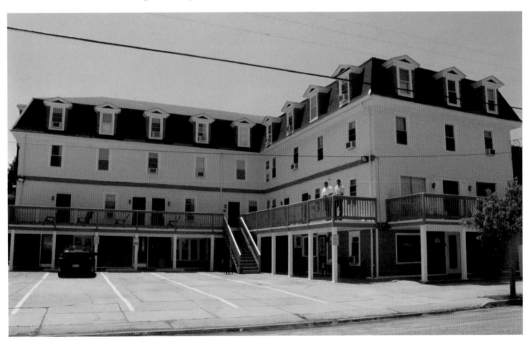

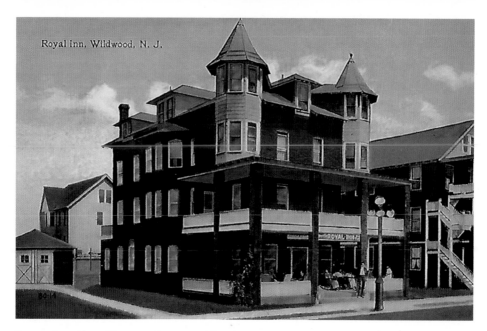

ROYAL INN, EAST YOUNGS AVENUE, WILDWOOD: The Royal Inn was a fitting name for this castlelike hotel. Through all the changes in ownership since it was built *circa* 1903, the Royal Inn has always kept its name. One of its earliest proprietors was Joshua S. Bush, born in 1853 and raised in New Brunswick, who came to Five Mile Beach at the turn of the twentieth century. Joshua S. and wife Annie raised their youngest children, Millie and Joshua Jr., in the Royal Inn. In a 1927 issue of the *Pittsburgh Post-Gazette*, Bush reported "exceptional early season business" and considered opening the hotel year-round. Joshua S. died in 1935 and is buried in Fairview Memorial Cemetery in Cape May Court House. *(WHS)*

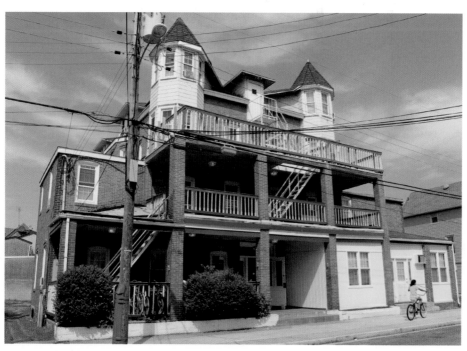

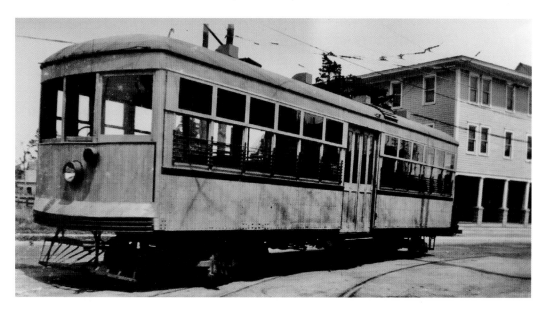

HOLLY BEACH HOTEL, EAST SPICER AVENUE, WILDWOOD: The land on which this hotel was built was owned by Burdette Tomlin, a Millville businessman for whom the hospital in Cape May Court House was named for several decades. In 1905 Tomlin sold the lot to Charles Fox, who built Rowland Hall, a thirty-five-room boarding house, in 1906. The town trolley barn was just across the street. In the decades to come, ownership changes led to name changes, including Spicer Hall and Holly Beach Hotel. By 1988, it was in need of major upgrades, but Cindy and Robert Buziak saw potential. They ripped out paneling and wallpaper to discover original banisters and walls, and restored the Holly Beach Hotel to fit the Victorian era when it was built.

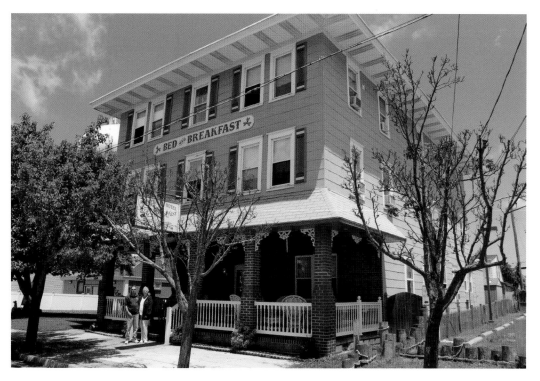

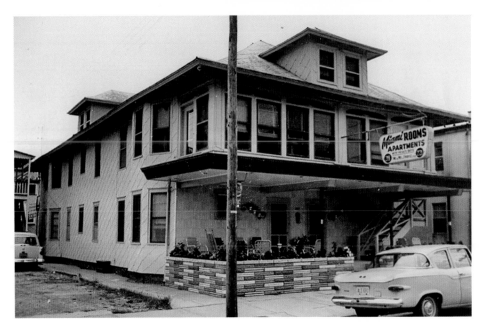

MANGOS HOUSE, EAST SPICER AVENUE, WILDWOOD: Like single-family homes, apartments and boarding houses built during the 1920s boom utilized the Craftsman style. This foursquare apartment, built *circa* 1920, is a prime example. Its name and ownership changed a few times, ultimately becoming Shore Apartments when purchased by Manny Mangos in the mid-1980s. Mangos, born 1926, came to Wildwood when he was twenty. He had built the Mango Motel next door to the Shore in the early 1960s and managed it for decades. Mangos still runs the Shore and oil paints in his spare time. His artwork covers the walls of the Shore. Like many apartments now, the Shore is home to seasonal workers traveling with J-1 visas. *(WHS 1960)*

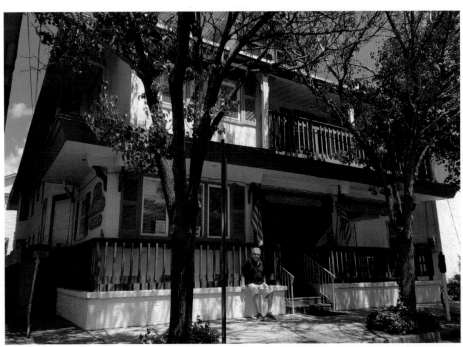

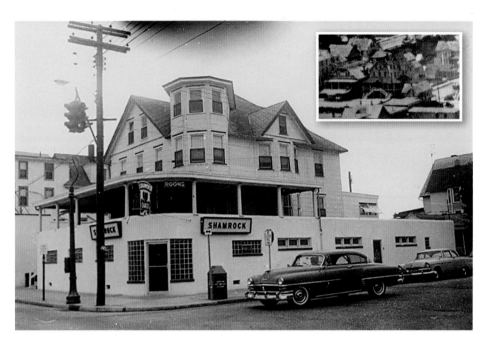

BERWIND HOTEL, PACIFIC AVENUE, WILDWOOD: Jeffrey Pellerin and Fred Davis partnered as Davis & Pellerin and built the Berwind Hotel in the 1900s. They ran the hotel until their partnership ended in 1924 and they sold to E. C. Smith. Grocer Louis Senekoff opened the second location of Senekoff & Son grocery on the ground floor in 1924. People who stayed here included Ruth J. Mathews, a housekeeper recently widowed from her husband George, and Frank J. Quirus, who ran Frank's Bakery at Hudson and Lincoln. In 1937, Cornelius Ward, an Irish immigrant born in 1893, bought the Berwind, moved in upstairs and established the Shamrock Cafe "for drinking and socializing." Inset shows 1909 aerial view. *(WHS 1960)*

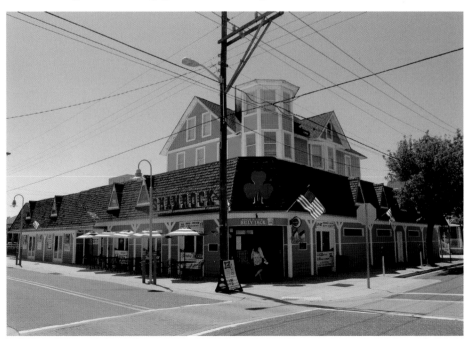

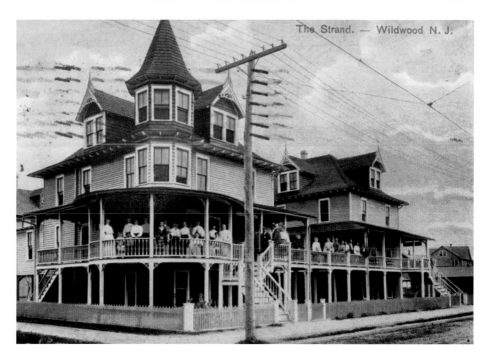

THE STRAND, PACIFIC AVENUE, WILDWOOD: Diners who enjoy their fried rice and dumplings at this Chinese restaurant are sitting in one of the early Victorian hotels of Wildwood. The Strand debuted in 1910 under the proprietorship of William Gertsel. When Gertsel left the Strand to buy the Savoy Hotel of North Wildwood in 1922, Bessie Braslow became the Strand's householder. She opened a clothing store on the first floor with Morris Satinoff, called Satinoff & Braslow. The Strand rooms were managed in the 1930s by Eva Rose with Franks Bakeries on the first floor. In the 1940s, Eva's son Robert took over and rented to Sara Asplund, who opened Ideal Restaurant downstairs. The Dragon House Chinese restaurant opened in 1959. *(WHS)*

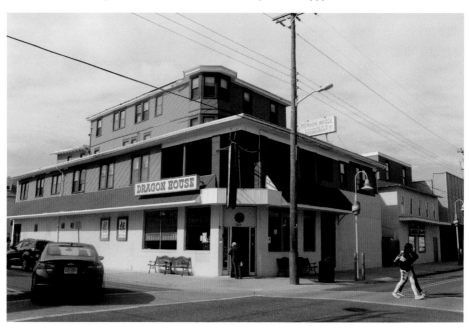

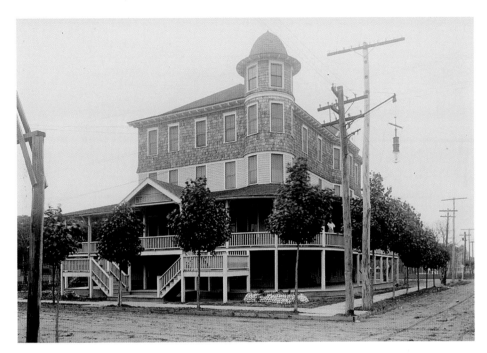

SEVERN HALL, PACIFIC AVENUE, WILDWOOD: Since it was built in 1900, Severn Hall has been run by women. The Victorian hotel, which boasted a "wide and commodious" 150-foot piazza, was established by fifty-nine-year-old widow Matilda B. Severn of Pennsylvania, one of the first female property owners in Wildwood. After her death, Severn Hall was managed in the early 1920s by Anna Cole, wife of Samuel Cole, then in the mid-1920s by widow Lillian W. Cole, and in the 1930s by Jennie M. Ferro. The first local A&P Store with a meat market opened on the hall's ground floor in 1927. In the 1960s, a cigarette fire damaged the top three floors, but the bottom two survived. Orlando Mattera bought the building in 1969 and razed the top floors. Since 1972, his widow Bridget has rented the upstairs to seasonal workers. In 2012, the city Board of Commissioners honored Bridget for "maintaining her property in an exceptional state of cleanliness." *(WHS)*

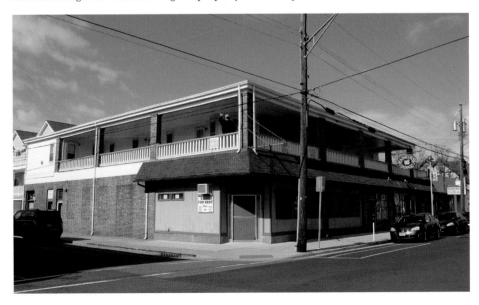

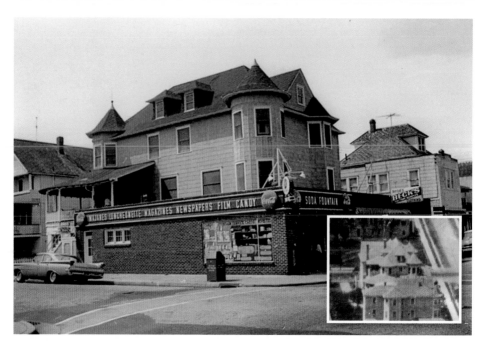

MIA MIA, PACIFIC AVENUE, WILDWOOD: This 1900s Queen Anne Victorian hotel, once operated as The Weldon by widow Louisa Welden, is now an Italian restaurant. Its ground floor was converted to storefronts as Pacific Avenue became the retail hub of town. Beneath the turreted towers, Milton and Harry Beck opened a produce shop in the 1930s. By 1960, it became Majane's Luncheonette and Beck's Factory Samples. Restaurateurs Vincent and Beth Chiarella brought their business here in 2006, naming the restaurant Gia's for their daughter who died at thirteen. Both Chiarellas died in 2016 and Gia's closed. Their daughter Mia fought for the building in surrogate court, reopened the restaurant as Mia Mia with partner Joe Schulte, and made the upstairs their home. Inset shows 1909 aerial view. *(WHS 1960)*

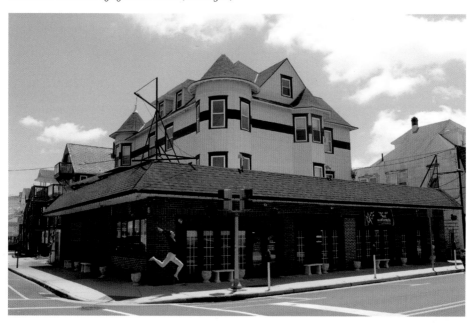

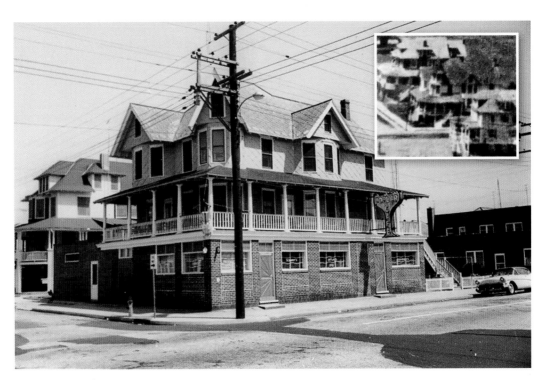

POPLAR CAFE, PACIFIC AVENUE, WILDWOOD: One of many fabulous Queen Anne houses built in the 1900s, this was the home of Otto and Lida Koeneke. Otto was secretary and treasurer of Koeneke Brothers Co., a plumbing supplier he founded with his brothers Harry and William. Before then, they were plumbers, and Lida was a confectioner. The bottom story was converted to storefronts where William Cave sold cigars until the 1930s, when the Poplar Cafe and grocery opened. It remained the Poplar Cafe until the 2000s, when it became Goodnight Irene's Brew Pub. Inset shows 1909 aerial view. *(WHS 1960)*

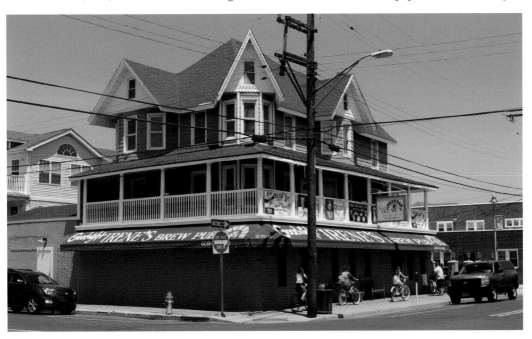

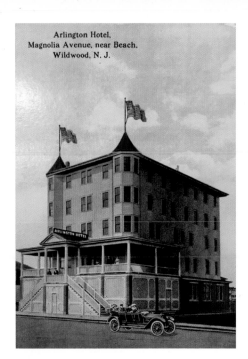

Arlington Hotel,
Magnolia Avenue, near Beach,
Wildwood, N. J.

HOTEL ARLINGTON, EAST MAPLE AVENUE, WILDWOOD: The Hotel Arlington has remained almost unchanged for more than a century. A late Victorian, it was built in 1912, a year after the Boardwalk was moved to create the 300 East blocks. It was one of the top Wildwood hotels in 1915. Because it was built in the teens, it was one of the few hotels that had running water and baths in all rooms. It was founded by Anna R. and Charles Howard Topham. Charles served as president of the Wildwood Chamber of Commerce, Hotel Association and Wildwood Golf and Country Club and was open bowling champion of the Philadelphia District in 1915. He sold his share in the Arlington after thirty-five years and became manager of OA Huf Fish Company at Ottens Harbor. He died in 1948. *(WHS)*

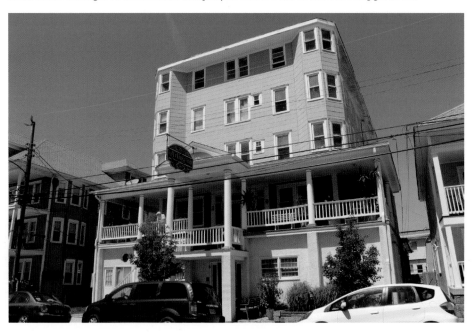

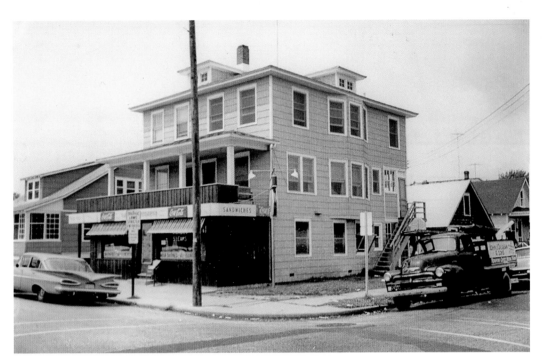

LARKIN'S LUNCHEONETTE, NEW JERSEY AVENUE, WILDWOOD: The beloved Larkin's Restaurant dates to 1949, and the house it's in is even older. Joseph J. Larkin served in World War II from 1943-1946, and returned to his hometown of Wildwood after his service. He and his wife Marian, a dance teacher, moved into this pre-1920 American Foursquare and converted the bottom floor into a luncheonette. Before urban renewal in the 1960s, business owners' living quarters were usually above their businesses. The luncheonette became Larkin's Restaurant and was passed from Joseph to his son Jay and Jay's wife Kathleen. *(WHS 1960)*

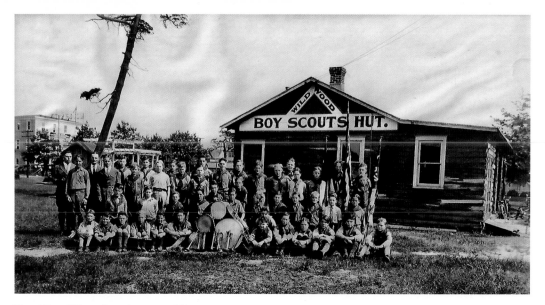

THE HUT, WEST OAK AVENUE, WILDWOOD: After a decade of meeting in the First Baptist Church, Wildwood Boy Scout Troop No. 1 built a log cabin in 1921. Architect Mark B. Reeves designed the Boy Scout Hut across from the train station, and local businesses donated lumber, a stove and keg of nails. Mechanics volunteered services on evenings and Saturday afternoons to complete construction. Dozens of Scout troops soon formed on the island, each using the Hut on different days. Fundraising problems coupled with scheduling conflicts among the troops ended the Scouts' tenure at the Hut. It became the Log Cabin Community House in the 1940s, holding political and civic meetings. Today it is the Twelve Step House, hosting Alcoholics Anonymous. *(WHS)*

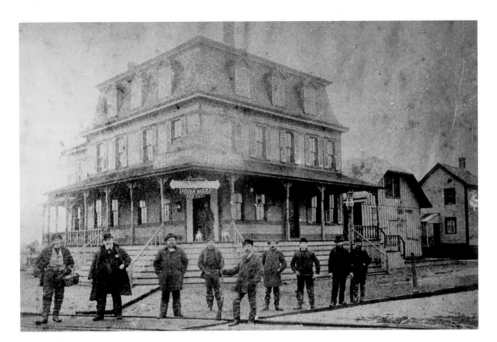

HOTEL GERMANTOWN, WEST 1ST AVENUE, NORTH WILDWOOD: Contractor Hewlett Brower built this mansard hotel in 1891, when the angler's town Anglesea was less than a decade old. George J. Ent bought it and founded Hotel Germantown, the "traveling men's home." After Ent died in 1918, his widow Laura sold the mansard to William and Catherine Bishop who ran the bar downstairs as Bishop's High Steps. Their son Louis, born upstairs in 1920, would become the oldest and longest serving member of the Anglesea Fire Company, which William helped found. After the Bishops sold in 1981, it became the S. A. Wade Tavern, then the Anglesea Pub. In 2016, Buzzfeed voted the Anglesea Pub the best Irish pub in New Jersey.

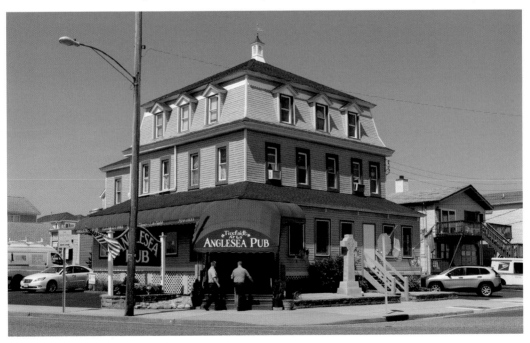

THE ATLANTA, SEAVIEW AVENUE, WILDWOOD CREST: Decorated with Greek Revival columns and entablature, this hotel was built on Atlantic Avenue in 1909. The building held two hotels: to the north was the Seward, owned by Victor J. H. Seward, and to the south, the Atlanta. Vacationers enjoyed strolls along the wraparound porch. In 1924, David McKibbin took over the Seward and renamed it the Fairview. Businesses opened downstairs, including Ethel Kelley's baths, Mary Wheaton's confections and Clara McCann's real estate office. In 1985, Dante and Marie Ruggiero converted the hotel into thirty-four condo units and renamed it Costa Del Sol. Later renovations partially obscure the building's history, but clawfoot tubs, hardwood doors and original skylights remain. The street was renamed Seaview when the receding oceanline allowed a new Atlantic Avenue to be built. *(WHS)*

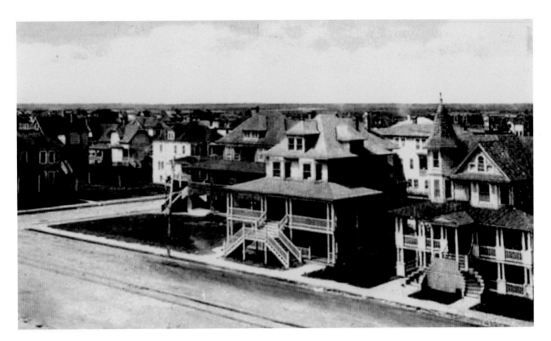

BRITTON'S BAKERY, PACIFIC AVENUE, WILDWOOD CREST: One of the most stunning Queen Anne Victorians in Wildwood Crest was built in the 1900s as the summer home of Alfred P. Smith. He was believed to be the same person as Philadelphia lawyer and historical archivist Alfred Percival Smith (1863-1944) who preserved and archived a vast collection of currency, photos, books and plans. In the mid-1920s, the house became the home office of realtor A. Blake. Today it is Britton's Bakery, run by the legendary Marie Britton. In 1983, President Ronald Reagan sent the bakery a letter praising the apple fritters. *(WHS)*

THEKLA HALL, EAST FORGET-ME-NOT ROAD, WILDWOOD CREST: John and Thekla Gloeckler immigrated from Germany in 1888, and John became a house carpenter at Five Mile Beach. He built a hotel called Thekla Hall, named for his wife, in the late 1900s. The Gloecklers ran Thekla Hall for decades, and in the 1950s, William and Josephine Birtch bought it and named it the Forget-Me-Not Hotel. William died that decade and Josephine ran it herself. Different families ran the Forget-Me-Not Hotel and Restaurant over the years, and in 2007 it was converted to condos. It received a Spanish-style makeover to match other Spanish houses in the Crest. *(WHS)*

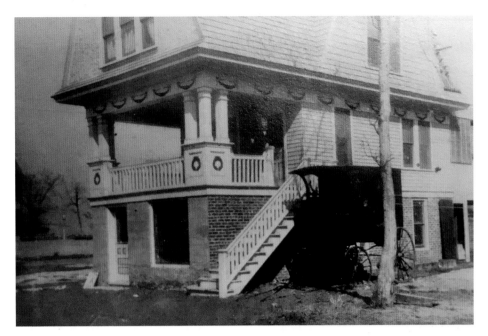

FIRST INGERSOLL FUNERAL HOME, WEST MAPLE AVENUE, WILDWOOD: Benjamin Charles Ingersoll of Tuckahoe went to the Massachusetts Embalming College to prepare for his career as director of Ingersoll Funeral Parlor on Five Mile Beach. He was also an "architectural draughtsman" with "years of experience as a builder" and "knowledge of every detail of Seashore Building." He built his first parlor, a Folk Victorian with gambrel roof, in Holly Beach in 1899. It also served as the Ingersoll family home, where they "very pleasantly entertained friends" as reported by a local newspaper in 1905: "Various games were played after which the guests were invited to the dining room to partake of a fine collation of toothsome eatables." Since 1978, it has been the home of Tom and Janet Felke. *(WHS)*

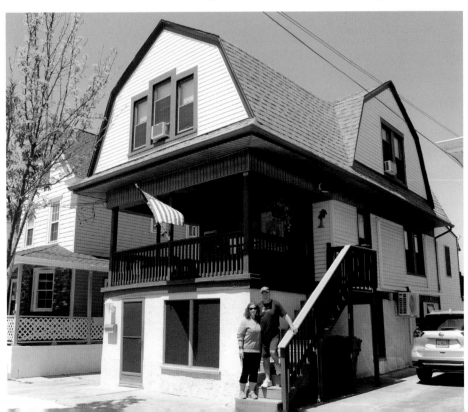

GEORGE BOYER MUSEUM, PACIFIC AVENUE, WILDWOOD: In 1906, B. C. Ingersoll built an identical parlor at a more central location on Pacific Avenue and moved his business (and household) there. When he died in 1924, his son Benjamin Jr. became director of the funeral home. Benjamin Jr. was mayor of Wildwood from 1941 until his death in 1945. His sons Benjamin III and David C. took over the business in 1946 after returning from serving in World War II. They retired in 1973 and David C. Jr. took over the business, moving it to Central Avenue. This building served as a retail store until 1990, when the Wildwood Historical Society, founded by George Boyer, was moved from city hall to this much larger space. Its expansive collection continues to grow. *(WHS)*